To Gail de Lima

When you were 28½

WENDY

January 26, 1980

Gail,

When you were 28½.

WENDY.

PHOTOGRAPHY

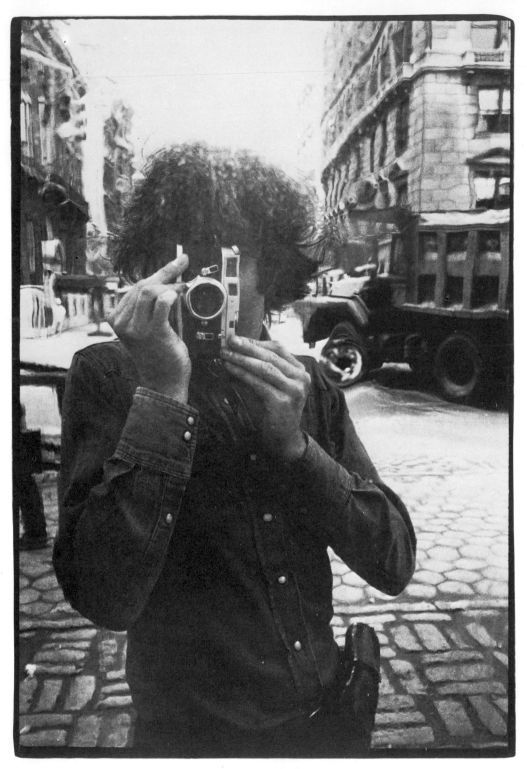

Photographer's reflection in an aluminium sheet in New York.

Warne's Art and Craft Series

PHOTOGRAPHY

MARK EDWARDS

FREDERICK WARNE

First published by Frederick Warne (Publishers) Ltd, London, England, 1977

ISBN 0 7232 2063 8

Filmset and printed in Great Britain by BAS Printers Limited, Over Wallop, Hampshire.
2620·777

Contents

I. Stopping the World

Anyone picking up this book is likely to have had some experience of photography, possibly starting on a very simple, inexpensive camera. This is how I started. The first photograph I took was of my cat, and four days later there was the picture, everything arranged just as I had seen it through the small glass viewfinder. For me it was like taking part in an amazing conjuring trick. I was overwhelmed by the way the camera had held on to that moment four days ago and changed it into a picture on a piece of paper. The earliest photographers were so excited by the process that they spent hours comparing details in the picture with the real life objects. That excitement has been shared by millions of people during the hundred and fifty years since film was first loaded into the back of the camera.

Since that time photographic styles have changed as dramatically as has camera design. As the new, easy-to-use cameras and fast films began to fill photographic shops, opening the door to a more fluid use of the medium, photography became literally child's play. The energy that had fired the more traditional amateur—who was self-trained and possessed a strong sense of classical values and manipulative techniques and whose work was mainly of interest to other photographers with similar backgrounds and aims—was seen to diminish. In the course of a few years hundreds of closely guarded techniques became unnecessary clutter, regarded by the new camera owners with nothing more than distant respect. *

For most people whose interest in photography extends a little beyond the family snapshot, the newspaper or magazine photograph has come to provide the standard and direction for their work. Sadly, these 'trend'-setting photographs have often little more to offer than the static pictorialism produced with such

*See Geoffrey Crawley's leader in the *British Journal of Photography*, 28 May 1976.

To my parents and brother, who were the first to have my camera pointed at them and who helped and encouraged my journey into photography.

excitement a few years ago. A more important development, spearheaded by some extremely imaginative photographers, working mainly in the United States and Europe, suggests the use of the camera as a major means of personal expression. *

This movement grew out of the decline of the general interest picture magazine which had used photographs to focus readers' interest and attention on the stories they illustrated.

For some years photographers outside the documentary and commercial areas had no vehicle for communication, but gradually forward-thinking people opened galleries and a number of small-circulation magazines were created for the purpose of exhibiting photographs. Nowadays more photographers are beginning to look for income from sales of original photographic prints and slowly this market is growing. Certainly, well chosen photographs from this period will increase in value, but at the moment this astonishing revolution is largely unnoticed by the majority of camera users. Paradoxically, these photographs are as yet mainly of interest to other photographers with similar backgrounds and aims, but a coherent photographic aesthetic is being formed, which encompasses the best of the work produced in the traditional reportage and pictorial area and also includes work that has more to do with the photographers' individual emotional reaction to their world and their experiences.

What I strongly hope is that people interested in photography will not try to tailor their own work to fit the established and accepted styles, or some newer movement that may happen to be fashionable. To my mind that is the least rewarding direction to take. Portable photography is only fifty years old and in a sense we are all pioneers of this extraordinary medium. The fun is to find ones own visual language. Readers wishing for a visual formula to adopt will find this book disappointing. Formulae help the photographer to master the craft side of the process. Technique—lighting, exposure, processing, etc.—is measurable, and the accomplished photographer must be able to react with the right technique, sometimes extremely quickly. It is only when a thorough understanding of technique, or rather many techniques, has been acquired that perfect expression may be given to one's visual observations. Technique serves to make material the image observed through the viewfinder. In photography the emphasis must be placed on observation. Photography is always a response to actuality, and to respond intelligently to the world the mind needs

*See Paddy Summerfield's *Oxford*, a review by Gerry Badger in the *British Journal of Photography*, 30 July 1976.

You do not need an expensive camera to photograph your friends or observe people.

to be free to see with attention (an essentially *receptive* state—not to be confused with a state of *concentration*, which involves a deliberate shutting out, a choice of one aspect of events at the expense of others), and in that state, uninfluenced by style or fashion, choose the most powerful way of re-seeing the events around it. Visual rules are a burden; they fix ideas, blinker the eye and slow the mind. One needs to be confident technically and that comes only with practice and learning. The hands and the eye join at the camera and, through the viewfinder, there comes a sense of being joined also with the events around one. It may be that you are trying to orchestrate a lot of activities in one cohesive image or looking for the moment when the juxtaposition of simple, ordinary events reveals a startling image. Sometimes you go straight for the master photograph; sometimes you have to peck away at the subject until it yields the picture that combines the intellectual, factual content, with its correct abstract, geometric counterpart. Sometimes you walk all day without seeing a single picture; then suddenly it is there in front of you . . . a few seconds go by and perhaps you have in your camera a photograph that will last in your folio for ever.

The root meaning of the word *art* is everything in its right place, a sense of order. Composition can best be understood by careful attention to the heritage of work left us by generations of artists and more recently this includes, by general consent, examples of the best work by leading photographers. Just look at pictures, let them speak to you, do not analyse them mathematically; it is more fun to let them speak with their own voice.

A special sense, upon which the visual arts depend, stems from the facilities which evolution bred into the hunter. The good hunter, like the good photographer, is able to blend with his surroundings, working patiently, silently and economically. For a lesson in photography watch a cat stalk its prey, following every move, taking note of every detail of the victim's behaviour, edging into position, until the moment has arrived to make the jump.

I talked some years ago to a man who smuggled gold from Pakistan to India. He explained that he got through customs by making himself invisible. What he actually meant was that he withdrew psychologically, erasing every trace of flamboyance. While anyone could look at him, no one bothered. It is valuable for the photographer to learn to work like this. There are many occasions when the 'invisible' photographer will be allowed to continue his work when others would have been turned away. To work immaculately with the camera is a reward in itself, and the pictures you make are a gift from the world of chance.

With an eye for the unusual, the intimate and the trivial and with a little understanding of camera and film you can preserve and share these events forever.

14

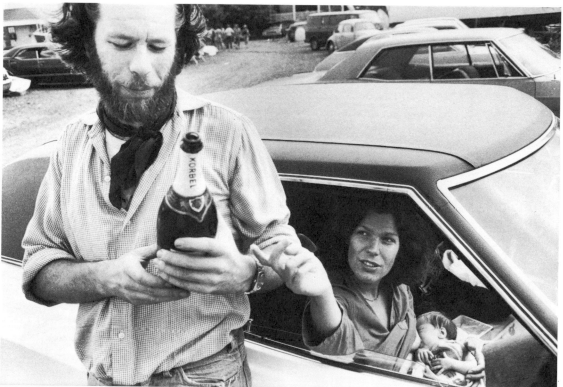

Photography is one of the hobbies in which the amateur can compete on equal terms with the professional. Pictures taken from your daily life may just as well extend the boundaries of photography, contributing a valuable folio that may be looked at alongside the best work created in the short history of the medium. Good photographers do not require expensive cameras or difficult techniques. An eye for the most revealing moment is the most important accessory.

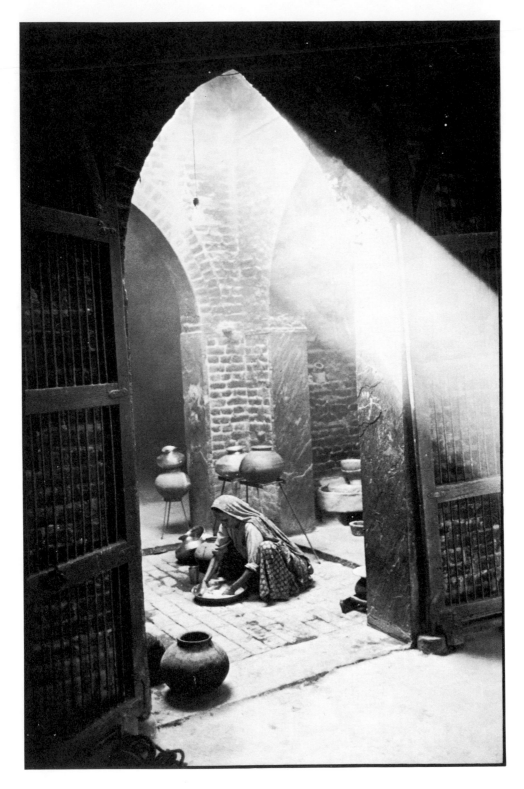

II. The Camera

The camera industry is big business. There must be thousands of different cameras being manufactured around the world. At first glance, the larger photographic shops seem to stock a dazzling range of equipment, but on closer inspection it falls into four main groups. When choosing a camera, it is helpful to understand the different features of the cameras within those groups. A photographic image can be made of virtually anything the human eye can see, and beyond. Different camera systems are designed to cope with the photographer's particular requirements.

Regardless of its shape, size or film format, a camera is a light-proof box, holding on one side a lense which shines an image on to the opposite side, where there is a mechanism for holding the 'light-sensitive' film. A shutter prevents the image from shining on to the film until the shutter release button is pressed; then the shutter opens allowing the image to shine on the film long enough to make the exposure. Since this time will vary according to the light, the sensitivity of the film and the lens, provision is made on all but the cheapest cameras to alter the exposure. The more you pay, the larger the range of shutter speeds you will find on the dial.

The lens has a variable hole or aperture to control the brightness of the image shining on the film and, again, the more you pay the more the aperture can be varied. The viewfinder shows the scene the lens is presenting to the film. There is also of course a lever to wind the film through the camera after an exposure has been made.

Film Size

Technological advances and economic changes have altered the size and shape of cameras and the size of the film which goes into them. In the early days the lenses were not very sharp, and the film could not stand much magnification before the image deteriorated. Hence enormous cameras producing negatives up to (40·6 cm × 50·8 cm). 16 in × 20 in. Nowadays very small negatives give excellent results even when they are enlarged many times. So cameras get smaller and use less film, which is lucky because the film, which is made from silver, is getting more expensive.

The photo on the left was taken with a small reflex camera. The image on the 35 mm film can be enlarged to considerable size without loss of quality.

The most popular size is 'thirty-five mil', designed initially for professional motion picture cameras, and gradually introduced to still photography as film stock and lenses improved. You get a picture 24 mm × 36 mm on film 35 mm wide. Most magazine and press photographs are taken on cameras using this film size and big enlargements 40·6 cm × 50·8 cm (16 in × 20 in) and over are possible. Colour transparency film can be projected to give a picture at least 1·8 metres (6 ft) across, with good definition. A wide range of film is available in camera shops all over the world, and for most people this format is the ideal choice. Also, because it is so popular, a wide range of equipment is available to take this size of film, which is sold in cassettes for simple loading into the camera.

Sub-Miniature Formats

These again use a film designed for movie cameras. The equipment is very small, producing negatives on film only 16 mm wide. The same degree of enlargement that produces a postcard-size print from a miniature negative gives a 40 cm × 30·5 cm (15 in × 12 in) print from a 35 mm negative. The structure of the film becomes visible with larger prints and little detail shows. (All right for special agents in the movies, though!) The 126 cartridge camera, which can be loaded in seconds, takes square photographs 26 mm × 26 mm. Although this format was largely designed to replace the box cameras, expensive and therefore more versatile cameras are available that use this film.

In the Single Lens Reflex camera an angled mirror reflects the image through the lens to the viewfinder.

Half-Frame Cameras

A good format if small prints are all that is required, but again less suitable if enlargements are to be made. These cameras take standard 35 mm film, but produce an image, as you would expect, only half the size of full-frame 35 mm cameras. A factor often overlooked is that a portion of a 35 mm negative can be enlarged satisfactorily, but the minute you 'crop' a half-frame or miniature negative, you start producing abstract, grainy pictures, whether you want to or not!

120 Roll Film

Cameras taking this film are popular with commercial advertising and fashion photographers, for whom quality is particularly important. You get larger negatives or transparencies— 6 cm × 6 cm—which of course cost more.

This photograph was made on a twin-lens reflex camera giving a negative 6 cm ($2\frac{1}{4}$ in) square. These cameras are difficult to use and the square format awkward to compose in. The larger film size has the advantage of better quality (compared to 35 mm) but of course costs more. Occasionally it may be interesting to experiment with but I would not recommend it as a general-purpose camera.

20

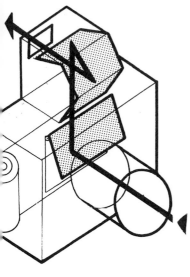

35 mm Single-Lens Reflex System

Without doubt, more thought has gone into designing cameras within this group than any other. As its name indicates, there is only one lens used both for viewing and for taking the photograph. The image seen in the viewfinder is, therefore, exactly the same as the one the film receives.

When the shutter release button is pressed to make the exposure, an angled mirror reflecting the image from the lens to the viewfinder swings out of the way, the shutter opens, makes the exposure, closes, and the mirror swings back. The whole operation takes a fraction of a second. Because you see exactly the image the film sees, though not at the moment of exposure, a very wide range of different focal length lenses may be used without any problem. The focal length of a lens is expressed in millimetres. For 35 mm cameras, lenses marked between 45 mm and 55 mm are known as standard lenses and, with this lens on the camera, there is no

apparent change in perspective. Its angle of view is based on that of the unmoving eye. Wide-angle lenses are those marked 35 mm or less when used on a 35 mm camera. They take in more of the world than the standard lens and are very useful when the distance between camera and subject is limited. A telephoto lens—on a 35 mm camera any lens marked more than 85 mm—sees less of the world than a standard lens, but magnifies the view it takes in. It is used by many people for photographing subjects difficult to approach closely, animals for example, and for sports events, but has many uses. Lenses are more fully discussed in Chapter III.

A feature that has helped make SLR cameras popular is the wide range of situations in which they can be used. They can take extreme close-ups with no difficulty; they can be attached to telescopes and microscopes. They are quick to operate and reasonably small, so reportage press and sports photographers favour them. And an astonishing range of accessories and lenses are made for them; these include motor drives, built-in exposure meters, waist-level viewfinders, and many, many lenses. The disadvantages are that most of them are showy and attract attention,

The Bangladesh war photograph and the photograph of Indian farmers on page 25 were taken with an SLR camera.

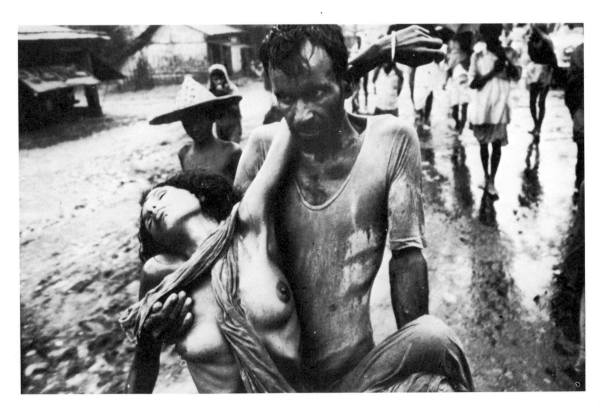

and compared to 'viewfinder' cameras they are noisy. Single-lens reflex cameras are in fact available in other formats, but these are produced in small numbers primarily for professional photographers, and are very expensive.

35 mm Viewfinder Cameras

The distinctive feature of these cameras is the separate viewfinder placed usually above and to one side of the lens. This means that they suffer from the problem of parallax—i.e., the film 'sees' a different image from the photographer. In expensive cameras a frame line within the viewfinder moves to help compensate for this error. It only becomes a problem when the photographer is working close to the subject with a normal or telephoto lens.

These cameras are small, unobtrusive and quiet, and some manufacturers offer a limited range of interchangeable lenses for them. Focusing is usually done with a built-in range finder, which is clearly visible even in very poor light.

As with the SLR, there is a wide range of cameras to choose from, though the majority are at the less expensive end of the market.

The cheaper mass-market cameras are all made with separate viewfinders. The more expensive viewfinder cameras are popular with a small group of discerning photographers, who value the unobtrusive design, quietness, speed of operation and craftsmanship that have gone into the manufacture of these cameras.

Twin-Lens Reflex

These are bulky, awkward cameras to use. The image in the viewfinder is laterally reversed, i.e., what is to the left in the world is to the right in the viewfinder. They produce square photographs, which most people find difficult to compose in, and use roll film, which gives only 12 pictures before another roll has to be loaded (as against 36 on a 35 mm camera). Frame for frame, they are more expensive than 35 mm, but give you better quality prints and transparencies. Once again there is the problem of parallax, because the viewfinder lens is in a different position from the taking lens. Only one manufacturer makes an interchangeable lens system.

Many established 'high street' photographers use these cameras for weddings and occasional industrial work. They are slower to operate than 35 mm cameras, but their design permits a wide range of holding positions and a very large viewfinder.

In the Viewfinder camera the image is seen separately, not through the lens.

In a Twin Lens Reflex camera the image is reflected by mirror through a separate lens.

23

Instant Photography

Polaroid, and more recently Kodak, manufacture special cameras and film that produce finished colour or black-and-white prints seconds after exposure, without any extra darkroom equipment. The prints can be copied to give enlargements or duplicates. So for people who want to take casual photographs of their holidays it could be the ideal choice. You know on the spot if you have correctly exposed the film or if you have framed the picture badly. There is also the pleasure of showing friends the picture you just exposed. But it costs more, about double the price of a conventional print.

Both Polaroid and Kodak instant colour film give beautiful results, and professional photographers have used large format Polaroid materials for portrait and more formal photography as well as for testing lighting and exposure for exacting studio photography.

The disadvantage is not having a negative to make a conventional black-and-white print from, and having the camera out of action while the print is ejected. So often it is necessary to be able to shoot in rapid succession.

Buying Secondhand

Most photographic shops sell secondhand cameras at a price that varies between half and three-quarters of the price of the new equipment depending, very largely, on the appearance of the camera. Listen to the longest and shortest shutter speeds. If there is anything wrong, the shortest ones will not open and the longest ones will sound uneven. Compare, if possible, with a new version of the same camera. Check the film wind-on lever for undue slack and again compare it with a new model. Do not buy without a guarantee. A worn camera body does not always indicate a mechanically unsound camera, and a camera body in mint condition is not proof against trouble.

The big advantage of buying secondhand is that the camera and lens can be re-sold or traded in without much (or any) loss in value if you find that you have made a wrong choice.

Buying secondhand lenses is incidentally less of a risk, because of the relatively few moving parts. The focusing movement must be smooth, the aperture dial should not have any slack before altering

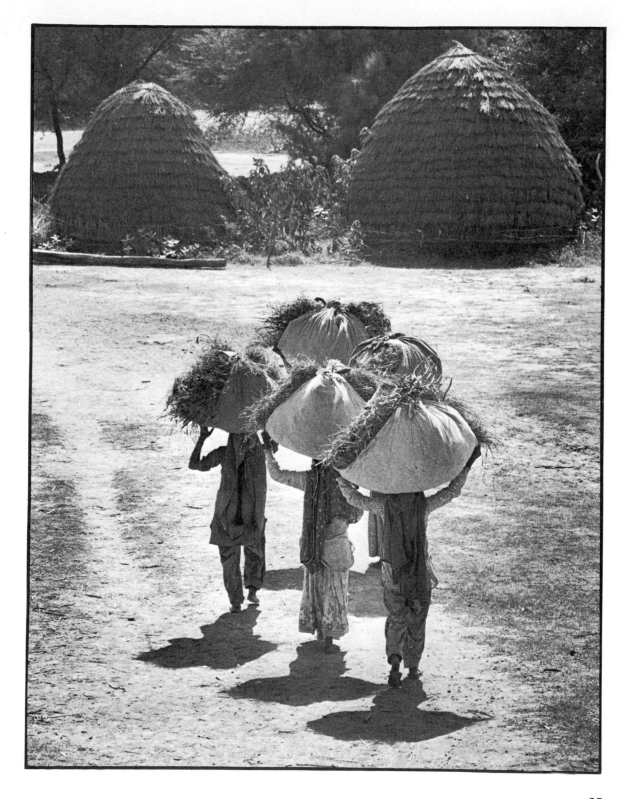

the diaphragm, and the glass should be unblemished. Check bayonet mounts for excessive wear both on the lens flange and on the camera body. Screw fitting lenses are slow to use but wear better.

Built-in Meters

Undeniably useful, particularly for colour transparency film where correct exposure is especially important. The most sensible design has a needle showing in the viewfinder, which you line up by changing either the shutter speed dial or the aperture dial. This system gives you accuracy, speed, and as much control over the final exposure as you have with unattached meters. However, it is the weakest part of a camera and tends to be the first to go wrong, so check carefully and look in the guarantee for any let-out clauses referring to built-in meters.

The camera market, new and secondhand, is dominated by 35 mm equipment, and this is the most satisfactory format for most purposes. Decide which are the most important priorities for the

To get the feel of the way different lenses see the world, look at these photographs. The photo above was taken with a 105 mm telephoto lens while the photo on the right was taken with a 50 mm normal lens.

26

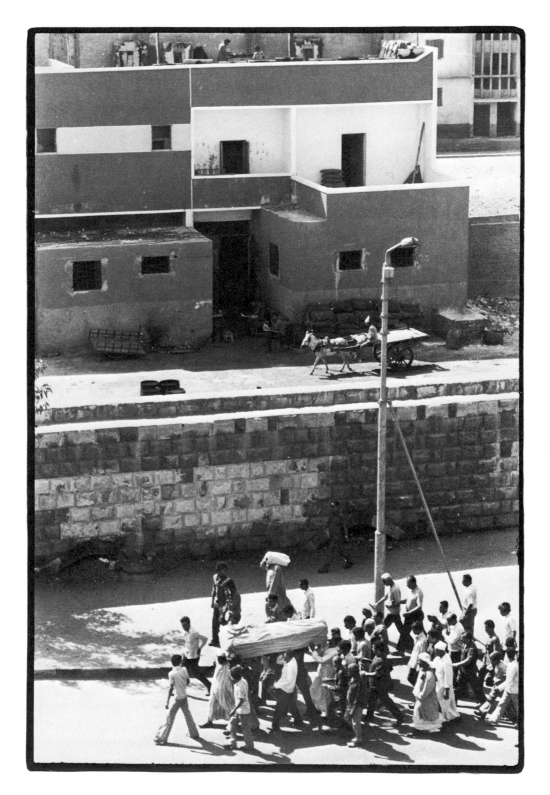

27

kind of photography you are contemplating, and discuss these with the dealer. Ask him about the guarantee conditions and the arrangements for repairing faulty cameras.

Choose according to your need. Visit more than one shop—prices vary as does the range of cameras, particularly the secondhand ones—and ask to see your friends' cameras. I do not recommend spending a lot of money the first time you buy a camera. Shop around for a secondhand one which does not stretch the bank balance to the point where you cannot afford film. A 35 mm viewfinder or SLR camera can tackle most situations, and later on, when you have more experience and a better understanding of your own photographic preferences, it could be traded in for one that more precisely fits your needs. Many people become obsessed with equipment. This is not photography as I understand it. Photographers, amateur and professional, are concerned with images. Whether the photographs are taken with a £20 mass-produced camera, or a £200 SLR with all the trimmings, the camera itself will

These two photos were taken with a 35 mm wide-angle lens.

not produce good photographs. Good photographs require keen observation, a lot of energy, a thorough understanding of technique, so that the mind is free to look at the world around, and a degree of luck—a little recognized but essential ingredient of all good photographs.

Holding the Camera

Before loading film into a new camera, get to know it. Learn how to release the shutter and advance the film in one smooth movement. When you press the shutter release button, do not jerk it down—squeeze it. Make trial exposures watching yourself in a mirror until you can see that the camera does not move when the shutter is open. If it is a long exposure, which means any shutter speed equal to or less than the focal length of the lens being used (i.e., 1/60 second with a 105 mm lens), special care is needed to ensure that the camera is held still.

Use breath control—let out half a breath, hold it, and gently press the button. Hold the camera firmly, but do not rigidly tighten the muscles in your body. Get used to finding the focusing ring and adjusting it without taking the camera away from your eye, and without moving the aperture scale by accident.

Getting to know any machine takes time. Cameras must be among the best examples of mass-produced precision engineering. They have been designed with the aim of functioning easily in a wide range of situations. Practise until your hands operate the camera by themselves, leaving your mind free to look. Photography does not begin with the camera, it begins with the eye and a mind that is curious to see the world. The first task of a photographer is to learn to hold the camera—become so familiar with it that it ceases to be separate from you. It must be part of you, like the clothes you wear. When a photographer is working well, the only thing he or she is aware of is the scene in the viewfinder. When you look with undivided attention, without force, or resistance, without the internal dialogue of the mind, the picture takes itself. Without thought you can act instantly, and this is the only way to catch those strange and astonishing moments that are photography's raison d'être.

The photo above was taken with a 28 mm wide-angle lens.

III. The Film

Photographic film is the light-sensitive substance that records the image formed by the lens. It is a wonderful product, which, like so much of the technology in use today, is too easily taken for granted. Even the manufacturers do not really understand how it works, but many substances change on exposure to light, and silver dissolved in nitric acid (silver nitrate) combined with a halogen element (chlorine, bromine, iodine, fluorine) is still the most satisfactory way of meeting the peculiar demands of photography. In fact, film reacts like your own skin, except that it is very much more sensitive. Like your skin, it darkens with exposure to light—physical pressure or bruising darkens it too—so it has to be handled gently in the camera and when it is being developed; and, like skin, different types of film vary in their sensitivity to light. One final analogy: scratches leave marks and are difficult to disguise.

There are many different kinds of film, and when you go to buy a roll you will be asked not only what size film fits your camera and how many exposures you want to make on the film, but also what ASA speed you need, what make, whether you want colour or black-and-white, and if colour, whether prints or transparencies. This is a somewhat daunting ritual at first, so let us take it question by question.

The size of film should present no problem if you have the camera with you. So we come to the ASA number. ASA is short for American Standards Association. It prefixes a number and you will find it on any box of film, black-and-white or colour, made anywhere in the world. It tells you how sensitive the film is to light. Photographers talk about the 'speed' of the film, and the larger the ASA number the faster the film, which means it is more sensitive to light; or, to look at it another way, a fast film needs very little light to produce a correctly exposed negative.

It is not necessary to know how manufacturers arrive at this number. Conveniently, the ASA speed doubles as the sensitivity of the film doubles. This makes it simpler to choose the right film for your particular needs. There is another system which you may see on your film box. It is called DIN and is again followed by a number. This is the German industrial system. Instead of the number doubling when the film speed doubles, it goes up by 3. As I am more at home with ASA, this is the system I shall be using throughout this book.

'Fast' films, colour or black-and-white, are more 'grainy' and do not give as much detail as the 'slow' films. This will not show so much on small enlargements but on big prints it will be very noticeable. Look at the photographs pp. 34–35. They are both taken with the same camera, and enlarged to the same degree. The picture of the Grand Canyon was taken on a slow film, 32 ASA, and the photograph of the man sleeping under Waterloo Bridge was taken on a special film made for police surveillance work; it is called 2475 recording film and can be rated at 3200 ASA. (It is made by Kodak and can be ordered through your local dealer.) There is a lot of difference between the quality of the two images. The first shows very fine detail and a long range of tones between the whitest and the darkest area. The second, taken at night with a street lamp for lighting, shows very little detail and a compressed or limited range of tones. Although the image was focused properly, the picture does not seem very sharp. This is because the emulsion that records the image breaks up into much larger dots on a fast film than on a slow film. Both photographs were taken at 1/30 second. The aperture was set to f/11 for the Grand Canyon and f/3·5 for the street scene.

All the photos here were taken on 400 ASA film. They show the extraordinary range of situations for which this material can be used, from poorly lit rooms to brilliant sunshine. Without changing films one can switch from bright sun to shadow.

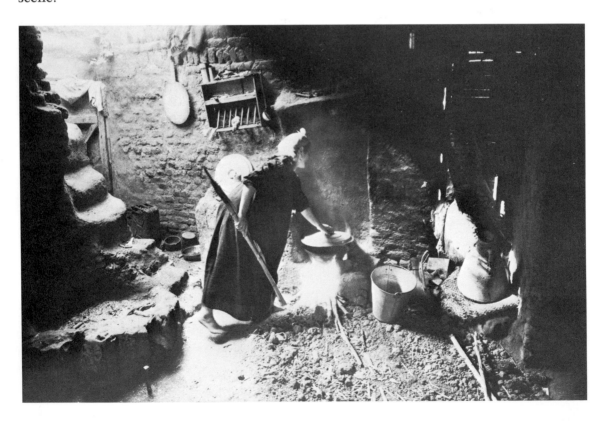

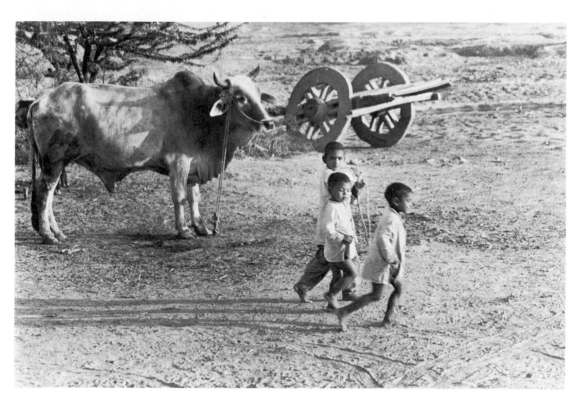

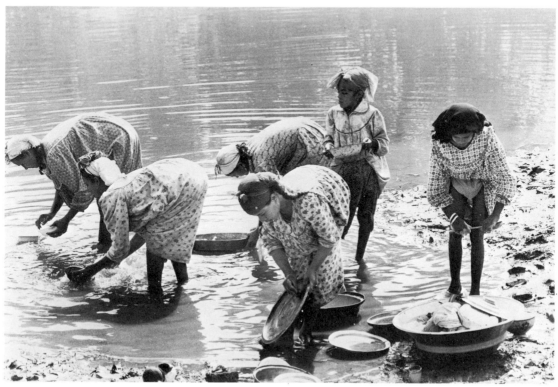

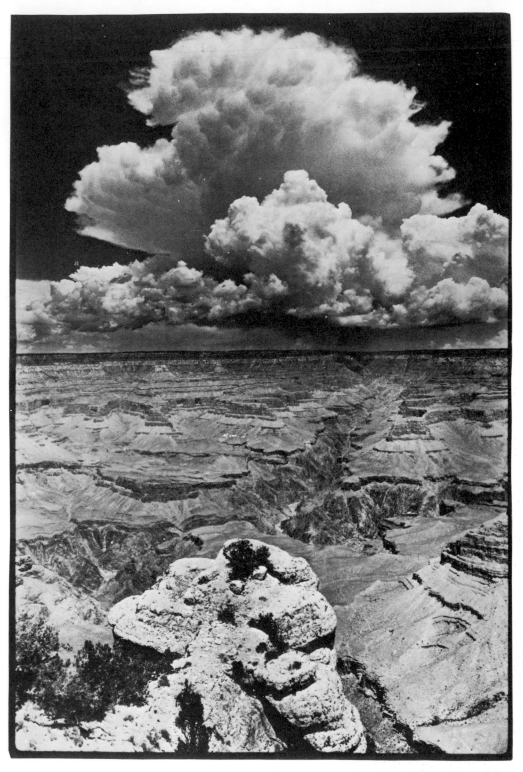

The photograph of the Grand Canyon was taken on 32 ASA film and shows fine grain and superb definition, needed in a picture including a lot of detail. The photograph on the right was taken on film rated at 3200 ASA (special police surveillance film).

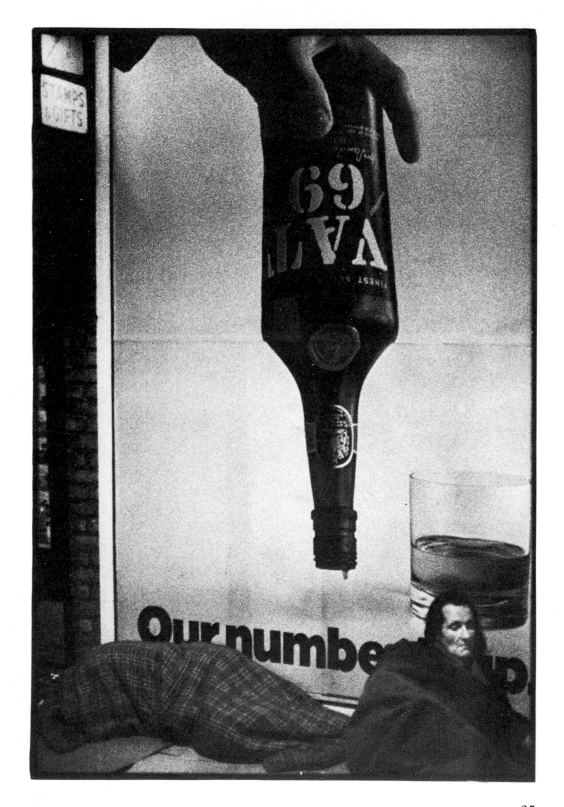

35

Fast	400 ASA upwards for night photography and general use in very low light when you are not using flash.
Medium	125—400 ASA for general use in bright and dull light levels and for action pictures. Can be used with flash or other light sources that the photographer arranges.
Slow	25—125 ASA when very good quality photographs are needed of subjects that are well lit or will not move if the camera is on a tripod.

'Graininess' is an unscientific way of describing the irregular dots photographs are made of, and, as we have said, the faster the film, the more noticeable the dots, and therefore the less detail is recorded. The graininess shows up more in photographs that include large areas of mid-grey or pastel colours, and does not show at all in the very dark or very light areas. You also get grainy photographs by enlarging small areas of negatives even from slow films. Slow films give you fine grain, all the sharpness your camera lens is capable of, and a long range of subtly different tones. This is

The photograph below was taken on 32 ASA film and shows fine grain, higher contrast and superb definition. Above right was taken on film rated 400 ASA and shows a slightly more noticeable grain but still retains excellent sharpness with slightly lower contrast.

Below right was taken on film rated at 1600 ASA and shows obvious grain, soft definition and lower contrast. However these differences will hardly be noticeable after these two photos have been printed, a tribute to modern fast films.

37

ideal when you want to make big enlargements, but you need plenty of light or long exposures, perhaps with the help of a tripod. This would rule out photography of, say, people running or moving fast, unless you wanted to show them as a blur. Generally, slow films are used for photographing static subjects, when very fine quality is needed, but they may also be used when you want to reduce the 'depth of field' (see p. 50).

Medium-speed films have the widest application because you can take photographs indoors near a window, or outside in shade and in bright sunshine. Developed properly they give quite fine grain and good sharpness. Personally I use a 400 ASA black-and-white film even when I work in countries like India, where it is very bright, because I never know when I am going to see something happening in a dark corner or indoors. In this way I can take nearly all the photographs on one type of film.

Fast films have been more recently introduced, and open up a whole new range of possibilities for the photographer. It is now possible to expose negatives at night using just street lamps, as in

The photograph from Nepal, below, was taken in a remote village in the Himalayas during a religious service. The tiny room was lit only by a few candles. The film was rated at 3200 ASA. The coarse grain and soft definition produce a picture that accurately reflects the atmosphere. The child sleeping in a makeshift hammock in a teapickers' hut (Sri Lanka) could not have been made without this extremely sensitive film.

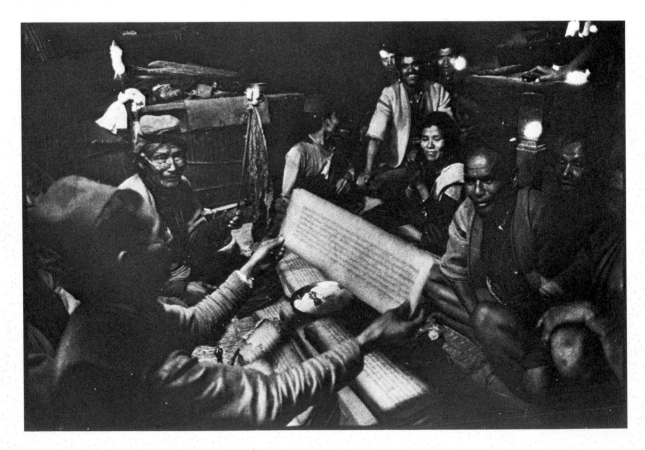

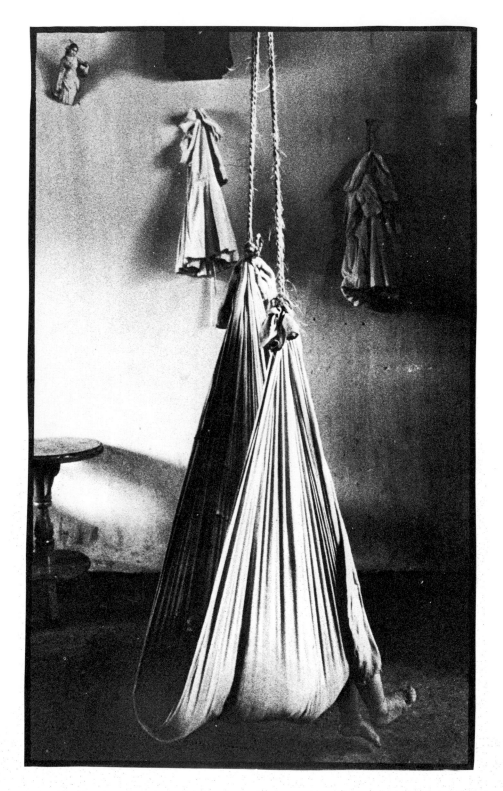

the photograph (p. 35). Also, very fast shutter speeds can now be used to freeze movement even in dull light and when using telephoto lenses; and small apertures can be used too in these conditions to give maximum depth of field.

Colour

In general what we have said about differences in quality between films of different speeds applies to colour materials. They are slower, however, and there are obvious differences in the way the various films record colour.

COLOUR NEGATIVE FILM is designed to produce colour prints, but can be used to make reasonable quality black-and-white prints and acceptable colour transparencies. You can choose between ASA speeds of between 50 and 400, the most popular being those at around 80 ASA.

COLOUR TRANSPARENCY FILM may be either projected on to a screen for large pictures, 1·8 metres (6 ft) across presenting no problem, or viewed through a magnifying glass in a table viewer which illuminates the transparency. Excellent colour prints can be made from transparencies using reversal colour papers (see Chapter VI). Black-and-white prints can also be produced, but quality is usually not very good.

These films are slower still. The most popular transparency materials are rated between 25 and 80 ASA. Anything over that is regarded as fast. Recently some very fast film has been made available designed to be used at 500 ASA.

As we have said, sharpness and grain size are not the only consideration when buying colour film. The way colour is recorded is for most people the main criterion. Experiment with different brands until you find one that gives you the quality you like.

Remember when you use transparency materials, the same piece of film that went in the camera ends up in the projector. It is available balanced to give natural results with daylight or two kinds of artificial light. The chapter on filters shows how to convert either kind of artificial-light colour transparency film to daylight or daylight film to artificial light (not recommended because of the 2-stop loss of effective film speed).

With colour negative film, colour balance can be adjusted, and to some extent errors in exposure can be corrected, during the printing. For this reason, different types of colour negative films produce similar results. Transparency materials, on the other hand,

Right: a black-and-white print made from a colour transparency shown on the back cover.

40

vary greatly. So here are a few comments that may help; they are subjective, so do not attach too much significance to them—what is important is your own opinions, based on your own experiments.

Kodachrome 25 and 64 and Agfacolor CT 18 and CT 21 are the giants of the transparency market, all are very sharp and fine-grained and on this score it would be hard to choose between them. All produce good skin tones and blue skies. Kodachrome probably produces the best greens and it has a quality that has been described as an openness which other films do not quite match. The colours look pure. The special quality of Agfacolor shows in photographs of rich, softly lift subjects.

My own favourite is Ektachrome. There are processing labs all over the world which will process this film, usually within two or three hours. It is not as sharp as those mentioned above, but produces lovely colours, bright and on the warm side, and it is very responsive to the moods of the day. High-speed Ektachrome, 160 ASA, gives very, very beautiful photographs in difficult lighting conditions.

GAF colour transparency films include GAF D500, the fastest colour slide film in the world—500 ASA. This excellent film

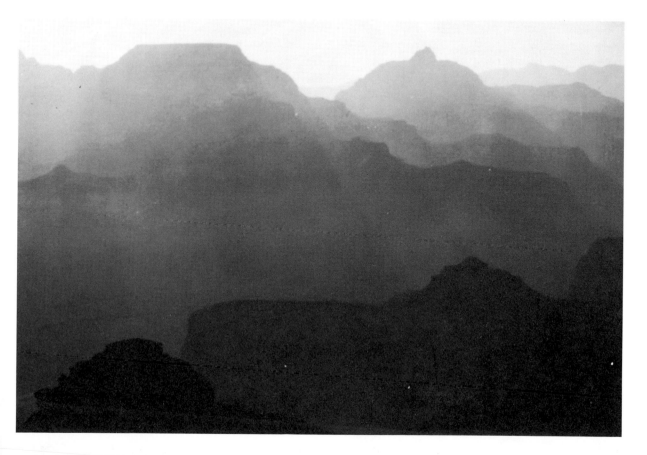

may unfortunately go out of production, but as long as it remains available it produces lovely rich colours and a softness which is most attractive.

Suddenly really good colour transparencies can be taken in low light conditions previously reserved by necessity for black-and-white film. The grain is noticeable but tends to enhance low-light pictures. GAF also produce a 200 ASA and a 64 ASA film, both good, and the manufacturer processes them all quickly, returning the pictures in plastic mounts. The only black-and-white reversal film is made by Agfa. I recommend this film as a way of easing into black-and-white photography and learning its peculiar qualities inexpensively. When you buy the film, you pay for processing, so there is no printing cost involved before the results can be assessed. Just project the slides and see how the pictures have come out.

I hope that now you feel able to choose your film with some confidence.

Right: the same photograph, normal exposure, under-exposed and over-exposed.

Looking after Film

Colour film, particularly transparency materials, requires special care. Sudden changes in temperature or storage in hot places (i.e., the boot or glove compartment of a car on a hot day) will damage it. Keep it cool and process as soon after exposure as possible. Airport X-ray equipment is another source of worry, especially in the Middle East countries where larger doses of X-rays can burn through special protection bags. Usually one exposure does no harm, but if it is exposed to more than five X-ray checks, you could find a density building up over the entire film. Insist on a personal search and wrap the film in bags impervious to the usual X-ray checks. This is particularly important if you use very fast film such as Kodak 2475 recording film. One dose of X-rays will affect the material, even though airport officials may assure you that it will not. Tropical humidity affects all film and is a curse. The gelatine swells with the moisture and becomes soft and easy to scratch. Exposed film could be sealed in a tin with silica gel which will help to absorb the moisture, but the best protection is fresh film, processed immediately after use.

Black-and-white film is wonderfully tough. Manufacturers will not like me for saying so, but it is almost indestructible. I have processed film months after I have used it in very hot climates, and the results have been perfect.

Return the film to the can after use and keep it safe until you can process it.

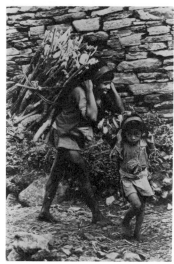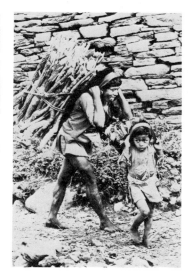

Exposure

The film is in the camera; now for the crunch. There are four ways of working out the exposure:

1. Use a light meter either built in to the camera or unattached.

2. Use an exposure calculator.

3. Use the exposure table that comes with the film.

4. Guess and hope for the best. (This can lose you pictures but it can also be more satisfying than the other methods, if you are lucky.)

Exposure theory is not really difficult but it is tricky—either you understand it, or you don't. Each roll of film you buy has a specified sensitivity to light (the ASA number, as explained on p. 31). It does not matter how much light there is outside the camera, your film always needs the same 'quantity' to produce a correctly exposed image. Imagine that you are taking photographs on a bright day (sun shining over your left shoulder, just as Kodak say it should), when suddenly a cloud hides the sun and the shadows disappear. You do not have to stop photographing, but you do have to allow the image to shine on the film for a longer period, i.e., turn to a slower shutter speed, and or allow the light to pass through a larger aperture in the lens so that a greater proportion of the light reflected from the subject gets to the film.

So far so good. It makes sense once you see the problem from the point of view of the film.

You will have discovered the aperture dial and seen the confusing scale of numbers:

$$2\cdot8 \qquad 4 \qquad 5\cdot6 \qquad 8 \qquad 11 \qquad 16$$

Each number closes the aperture in such a way that, reading from left to right, at each division the amount of light reaching the film is halved. Moving the dial from $f/2\cdot8$ to $f/4$ reduces the brightness of the image by half. So always remember: *the bigger the* f *stop number, the smaller the aperture.*

Shutter speeds, marked on the shutter speed dial in fractions of a second, are easier to understand. At each division the time the image may shine on the film is doubled or halved. The shutter allows the image that was squeezed through the aperture to shine on the film for a fixed length of time.

Expensive cameras give you a long range of different exposure times—from 1 second to 1/1000th part of a second or less.

Measuring Light

To recap before taking the next jump: the camera has two ways of controlling the exposure—the variable aperture in the lens, calibrated in f stops; and the shutter, which can be opened for a range of exposures calibrated in fractions of a second. The sensitivity of the film itself is known through the ASA number.

Before proceeding, one must understand why the exposure is important at all.

The purpose of getting the exposure correct is to produce on the film an image truthful to the original scene—giving transparencies with a full range of colours and plenty of detail, or, in the case of negative materials, good-quality prints requiring no complicated darkroom manipulation. Exposure affects the density, the amount of detail held by the film, the colours, and the relationship between the light and dark areas. It also affects the appearance of the grain and the overall sharpness of the photograph.

The exposure can be varied for a given subject and still produce acceptable results on either negatives or transparencies. The amount of latitude is largely dependent on the type of film (not the make) and the contrast of the lighting—contrast being the difference between the brightest and darkest part of the subject. To quote a standard example, a landscape viewed on a dull day may only have highlights 4 times brighter than shadows, while a room lit by sunshine pouring through the windows may have high-

lights 100 times brighter than shadows. When there are these large differences, greater care must be taken to get a realistic-looking photograph. Transparency materials require more care in exposure. They have less latitude than negative films.

Using a Light Meter

The correct exposure can be accurately gauged with a light meter. This measures the brightness of light either reflected from the subject (reflected-light readings) or falling on the subject (incident-light readings). This last method is usually recommended when colour transparency film is being used.

Two kinds of light meter are in general use—one with a CDS cell and the other with a Selium cell. The CDS meters use small long-life batteries and are very accurate in low-light conditions. The cell modulates the current provided by the batteries according to how much light falls on it. Selium meters need no batteries because a substance in the meter cell creates a small electrical current proportional to the light falling on it.

A light meter of either kind may be incorporated into the camera itself, but will have the same basic controls and parts as any unattached meter. Some cameras are totally automatic—the meter actually sets the shutter speed and aperture. On some alternative equipment a needle is lined up when the f stop dial or shutter speed dial is moved. To my mind this is preferable as it allows you more easily to exercise choice over the combination best suited to the subject.

The light meter will have a film speed dial for setting the ASA number so that the readings take into account the speed of the film, a cell to measure the light, and a scale to tell you what shutter speed and f stop combination you may use.

Setting the Dials

Move the ASA scale until the correct number appears in the window or opposite the arrow. This is very important; if it is wrong, all the exposures will be incorrect. Get used to checking this dial each time you start using the meter.

How to Use a Meter for Reflected-Light Readings

Taking care not to obscure the photoelectric cell with your fingers or the meter case, point the meter at the subject. For landscapes or street scenes, the reflected-light meter or semi-automatic camera with built-in meter would be tilted at an angle of 45° to the ground

to make the reading. The usual practice is to read the area most important in the subject. If it is negative material, base the reading on the shadow area, though not the darkest area as the film usually has enough latitude to record the rest of the tones. If it is transparency material, base the exposure on the lighter but not lightest parts of the subject.

How to Use a Meter for Incident-Light Readings

Most unattached light meters (unattached from the camera, that is) are sold with a translucent white hemisphere which, for incident-light readings, is clipped over the cell. With this attachment in place point the meter at the camera lens, preferably from the position of the subject, although out of doors the reading will be just as accurate if it is made from the camera position provided that the camera and subject are uniformly lit and the meter pointed in the same direction.

The reading is not influenced by the way the subject reflects light, but is determined only by the amount of light falling on the subject (incident!). As we have said, this method best suits colour transparency film and is often used in studios where candid photographs are not required and the slight extra time it takes to make the exposure is not important.

Setting the Camera

Let us suppose you take a reading on a bright day using a 400 ASA black-and-white film. The meter scale indicates a range of possible exposures—and it is at this stage that most people wish they had bought a completely automatic camera. This is what the meter shows when the reading has been translated into shutter speeds and apertures:

Shutter speeds	1/30	1/60	1/125	1/250	1/500	1/1,000
Apertures	f/22	f/16	f/11	f/8	f/5·6	f/4

Now any of these combinations will correctly expose the film. It makes no difference to the final density of the negative whether the exposure was made with a bright image shining on the film for a short time, i.e., 1/1,000 second at f/4 (an f stop of 4 passes a lot of light but a 1/1,000 second allows that bright image to shine on the film for only a very short time), or with a dim image shining on the film for a long time—i.e., f/22 (a small f stop) for 1/30 second.

At each numerical division on each scale the amount of light can be halved or doubled according to the direction in which the scale is

moved. Moving the *f*-stop scale from *f*/11 to *f*/8 doubles the amount of light passed by the lens, and moving the shutter speed scale from 1/125 to 1/250 halves the time the image can shine on the film. The trick with *f* stops is to remember that the smaller the number is, the bigger the hole. There is a logic to the strange sequence of numbers, although you have to be a mathematician to understand it. Although the *f* stop and shutter speed combinations indicated give negatives of the same density, there is pictorial difference. Essentially the *f* stop and shutter speed combinations interpret the subject in different ways. You choose according to the way you want to interpret the subject (see next chapter). If you cannot decide, take several photographs with different combinations. This is the best way of learning, and once you are familiar with the system, it is easy to judge the most effective combination. Obviously not all conditions give you a choice. In very dim light you have to use a long exposure and a large *f* stop.

Bracketing

With negative films it is really only necessary to 'bracket'—shoot an extra frame giving $\frac{1}{2}$ stop or 1 stop more exposure—when shooting subjects lit with contrasty light or ones that are 'back-lit'. With transparency film it is always advisable to shoot at least one extra frame giving $\frac{1}{2}$ stop less exposure. In contrasty light make one exposure according to the meter and one at $\frac{1}{2}$ stop less and one at a full stop less. The exposure guides that are sold with film can be successfully used, but only give information for a limited range of conditions. They have advantages however; they cannot go mechanically wrong or be pointed in the wrong direction! Moreover, they have no cell whose glass cover may be obscured by dirt or fingers causing deflated readings.

IV. More about Lenses and Shutters

In this chapter we are going to consider in more detail the lens and shutter, and how the various settings affect the pictorial quality of the image. We have seen how the interdependent action of the aperture controls and the shutter speeds gives the correct exposure. We have seen too that the different settings interpret the world in different ways. It is crucial to understand these differences in order to have a criterion for deciding which of the various shutter speed/f stop combinations to choose.

In the last chapter, we saw that the choice of shutter speed and f stop combinations available on a bright day using a 400 ASA film setting—1/1,000 sec. at f/4 or 1/30 sec. at f/22—would both have given a negative of the same density, but that the picture itself would have been different.

The photograph was taken at f/4 at 1/1,000 second. It shows the photographer Chris Steele Perkins perfectly sharp, suspended in mid-air, but the background is unsharp owing to the large aperture used.

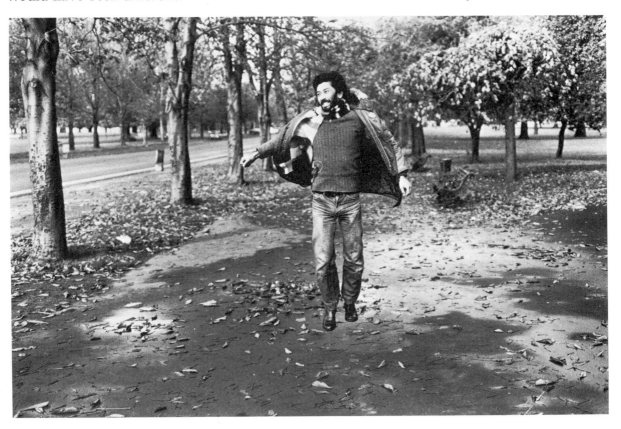

Let's say you were photographing someone jumping in the air. A shutter speed of 1/1,000 sec. would freeze all movement in the subject, simply because the amount the person moves in a thousandth part of a second is negligible. He would look perfectly sharp, frozen in mid-air. At 1/30 sec. the photograph would show a blurred image of the man, and if the camera were not held perfectly still during the exposure, even the trees would look unsharp. This is because, during the thirtieth part of a second that the shutter was open, the athlete would have travelled perhaps 30 cm. His body is shown moving through those 30 cm and the effect is an almost unrecognizable, elongated image of a man moving through the air. As you can see, two very different photographs, made simply by changing the shutter speed.

The absence or presence of blur is not the only difference between the two pictures. The photograph taken at 1/1,000 sec. at f/4 (short shutter speed, large aperture) is only critically sharp at the distance focused on. In front and behind that point the sharpness

Below right was taken at 1/30 second at f/22. The figure is blurred but everything else is sharply defined from foreground to far distance. The small aperture gives greater depth of field, but the slow shutter speed records only blurred movement.

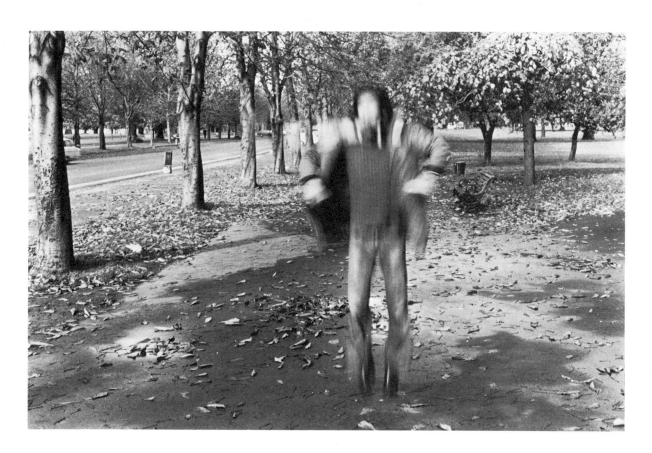

falls off rapidly. The photograph taken at 1/30 sec. at f/22 (long shutter speed, small aperture) is sharp from about ·9 metre (3 ft) to infinity. This effect is known as 'depth of field'. Depth of field is the distance between the nearest and farthest parts of the subject that appear acceptably sharp.

The greatest depth of field occurs when the f number is large (i.e., a small aperture), when the focal length of the lens is short for a given format (wide-angle lenses give the greatest depth of field), when the subject is distant and lastly when the degree of enlargement of the film is small. All these factors can be adjusted independently or in combination to give the photographer control over the final picture.

Have a look at the photographs. They show clearly how the zone of sharp focus changes with the focal length of the lens and the aperture. In each case the distance focused on was 1·2 metres (4 ft).

The astonishing depth of field obtained with a wide-angle lens used with a small aperture gives rise to an extremely useful technique called zone focusing. With a 28 mm lens on a 35 mm camera stopped down to f/22 and focused on 1·2 metres, anything from ·6 metre (2 ft) to infinity will be sharp. Even at f/11 with the lens focused to 2·1 metres (7 ft), everything from infinity to 1·2 metres will be sharp. A 50 mm lens set to f/11 and focused to 2·1 metres gives you a range of sharp focus extending from 1·8 metres (6 ft) to 3 metres (10 ft).

When you want to zone focus, select the aperture according to the light, bearing in mind the near and far distance you want sharp in the photographs you are working on. If your lens has a depth of field scale, set the focus not for a single distance but for the area of sharpness available with the aperture in use. Notice the nearest and farthest points that will be sharp and, provided that your subject is within this area, you do not have to touch the focus control. For lenses without a depth of field scale you may purchase a table separately.

It is surprising how much thought it takes before all this sinks in. But once it is there, it is extremely useful. It means, if the treatment is right, if there is enough light, and if you are using the 35 mm lens set to f/16 and focused on 2·1 metres (7 ft), that everything from 1·2 metres (4 ft) to infinity will be sharp.

If you want to pick out a face in a crowd and you are using the 105 mm lens set to f/4, there will only be an area of sharpness of a few centimetres in front and behind the point of focus, in this case 3 metres (10 ft). I am assuming in both these examples that it is possible to choose the f stop according to the pictorial effect

Depth of field Engraved on most lenses is a 'depth of field' scale. The diagrams show how the different length lenses and apertures alter the depth of field.

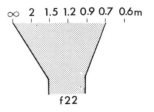

28 mm lens focused to 4 feet (1·2 m) aperture f/22 will record as perfectly sharp anything between ∞ and 2·5 feet.

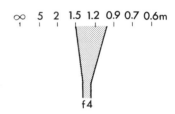

28 mm lens The same lens set to f/4 will now record as sharp only anything between 3·5 and 5 feet.

Top right: the aperture was closed to f/16 on a 35 mm wide-angle lens, focused to 6 metres. It allows almost the whole picture to be in focus, enabling the photographer to concentrate on his subject.

Below right: the same lens with the aperture set at f/4 gives little depth of field—even the people a few feet behind the accordion player are unsharp—so attention must be paid to the focus before the shutter is released to make sure that the principle parts of the subject will be sharp.

visualized, and that the exposure can be adjusted by using the appropriate shutter speed. As we all know, life is not always so simple.

An understanding of the depth of field is helpful in those conditions where you have little or no choice in shutter speed/f stop combinations. When there is very little light a long exposure and large aperture will be indicated. There is then little depth of field and any movement will show as a blur. Knowing this, you can take pictures that make a feature of the limitations. You can experiment in an entirely different way; instead of just hoping for the best and shooting blind you can begin to visualize the results and plan accordingly. Before long you will be able to see just as the film sees, and with more practice still you will know before you take the photograph the combined effect of the different shutter speeds and apertures. First try and understand the different factors separately, then fit them together. Then put it all into practice! A little experience and experimentation will enable you to become used to

Below: fast shutter speed was used to freeze all the movement in this photograph of Brazilian voodoo dancers.

Right: long shutter speed recorded half a second of this Indian classical dance as a blur.

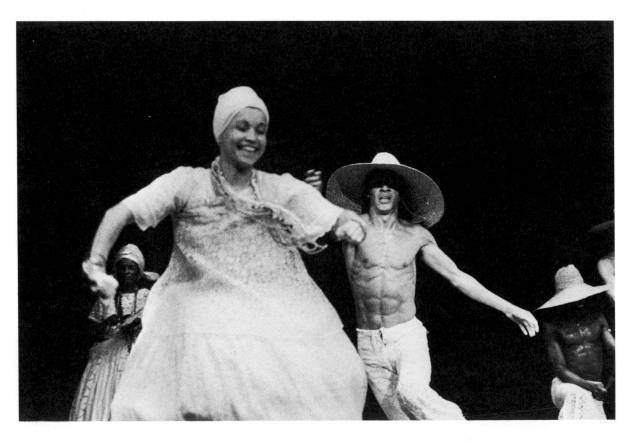

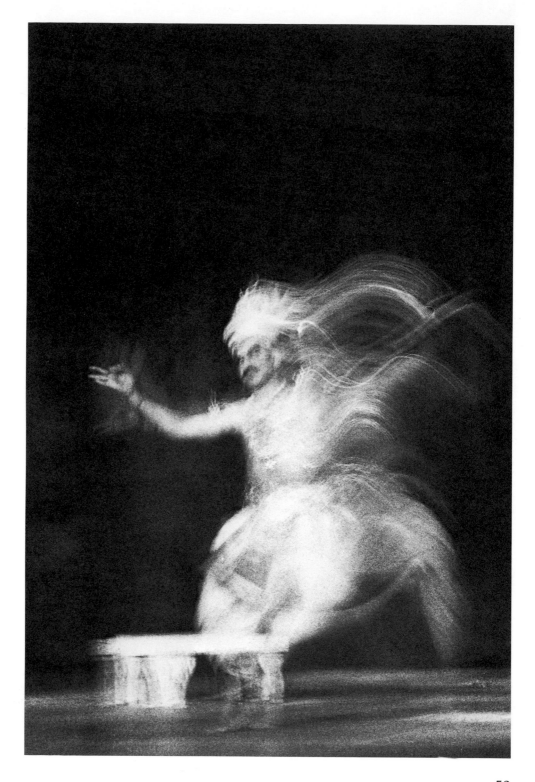

selecting the shutter speed that most closely interprets the scene as you want it shown. Decide how much blur, if any, you want and then set the shutter speed to work with the subject to produce that effect.

Movement across the camera records most noticeably as blur for any given exposure. Movement towards or away from the camera is least noticeable for any given exposure. A technique often used by sports photographers is to pan the camera vertically following for example a racing car. As far as the film is concerned the image of the car has stayed in one place and the background has moved. The effect, if it is done correctly, is of a sharp car and blurred background—an impression of speed as experienced by the driver is created. This technique needs care. Use a shutter speed of 1/250 sec. and start panning when the subject is still some way off. Release the shutter at the moment when the sweep of the lens equalizes with the subject.

Camera shake shows most critically with telephoto lenses and any lens used close to the subject because these magnify the world and the camera shake. There are various accessories designed to reduce or eliminate camera shake: tripods, chest pods, table clamps and mono pods. Beware of all the flimsy tripods on the market; they are sold because they are light and compact, but the least breath of wind at the moment of exposure and you have a blurred photograph. Sometimes it is possible to brace yourself against a wall and get away with exposures of $\frac{1}{2}$ second, but shoot several frames for safety. A useful device that can be made for next to nothing is a length of light-weight chain or cord attached to a bolt of a size that will screw into the tripod bush on the camera base plate. The end of the cord is held under a foot and the camera tensed against this has less chance of moving during long exposures.

Perspective—Focal Length

The term perspective refers to the change in apparent size of objects due to their relative distance from the viewer. Whole books have been written on the subject. Fortunately, as photographers we are not concerned with the rules set out by the Renaissance painters, but only with an understanding of the way different lenses see.

We know that the soldiers are in reality larger than the child, but on the photograph the child measures more than the soldiers. We have become used to interpreting the image our own eyes make, modifying the information through our experience; i.e., because we

We know that the child in the picture is really smaller than the men on the steps, but in the photograph the child measures more than the men. Because we know this we can gauge the approximate distance from the men to the camera.

know that the soldiers are in fact larger than the child, we can gauge the approximate distance from the men to the camera and so on. Wide-angle and telephoto lenses appear to alter the relationship between near and far objects, giving an untrue picture of the world. In fact, if you look at the contact print of a photograph taken with a 28 mm wide-angle lens and hold it 28 mm from your eye, that apparent distortion disappears. The flattening effect of the telephoto lens is strange until you see the picture from its 'correct' viewing distance. The photograph made with a standard lens looks perfectly familiar. You can obtain a telephoto effect simply by enlarging a portion of the negative.

Correct viewing distance is equal to the focal length of the lens multiplied by the degree of enlargement, and in the case of contact prints it is equal simply to the focal length of the lens. Correct viewing distance is not necessarily the most comfortable viewing distance, and I am not of course advocating that one should work out the distance from which to view pictures in order to make them

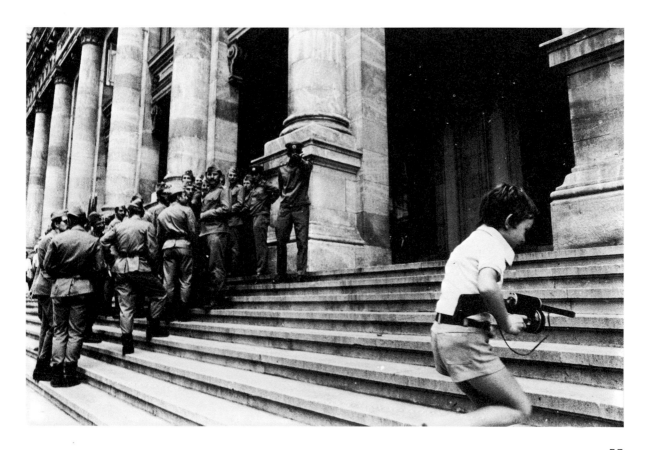

A

B

C

D

E

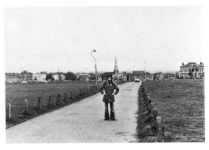

F

appear more real. What I would like to make clear is that the focal length of the lens does not in itself alter perspective.

Perspective changes when the camera moves. The three photographs D, E, F show a man the same size. Each picture was taken with a different focal length lens, and the camera had to be moved to keep the man the same size. Here it is the relationship between the man and the background which alters. If the camera were at a fixed distance from the subject, with only the focal length varied, it would be the size of the subject which altered.

Each lens sees the world in its own individual way—to use it properly you have to understand how it sees. The lenses in your eye project a crude inverted picture on the retina. We come to believe that this image is the world—that what we see is real. It is the photographer's task to understand the way he or she has been taught to see, label, interpret and recognize the world, and see with fresh eyes that are not hypnotized by words.

To recap: an important function of lenses of different focal lengths is to control the image size of the subject. Wide-angle lenses are useful in confined spaces and where extended depth of field is

Print A was made with a standard lens, B with a wide angle lens. Print C was made with a telephoto lens. The camera did not move, only the focal length of the lens has changed, altering the image size. Prints D, E and F show how perspectives are changed when the camera is moved to keep the foreground subject the same size. Each time the focal length of the lens is altered.

56

required; telephoto lenses are useful for subjects that cannot be approached easily; and normal lenses when you feel normal.

Apart from these specific purposes, the apparent distortion you get with different lenses may be felt to be particularly appropriate for certain photographs. To help towards a fuller understanding of the qualities of the different lenses page 56 shows a selection of pictures made with a range of different focal length lenses.

Light

Light is a form of 'energy on the move'. This energy enables us to view the objects around us and, when directed at photographic film, it produces, after chemical treatment, a visible image. Everything you do as a photographer depends on light. It is the raw material of photographic communication. Good photography demands an awareness and sensitivity to the way the changing qualities of the light affect the world.

The prime source of light is the sun and most photographs are taken with sunlight. There are many other ways of illuminating your subject but none that gives you the freedom of sunlight.

Because of the constantly changing angle between the sun and the earth the quality of sunlight changes throughout the day. The colour of the light alters and shadows change direction and shape. The visible spectrum, i.e., light as we know it, may be understood to be composed of a mixture of violet, blue, green, yellow and red light. A mixture of all or most of these colours or visible wavelengths is recognized as white light. The proportions of these colours change during the day. Photographers refer to the colour balance as colour temperatures of light, and there is a system of measuring the colour quality of light using degrees 'Kelvin'. Whereas our eyes are able to adjust to enormous changes in the overall colour of light, colour film is not. It is therefore balanced to give an accurate record in certain specified conditions, and when these conditions change the photographer has to use filters or different film. (Film manufacturers soon found that photographers bought film that made the family look suntanned. Daylight colour film is balanced to give white skin a healthy brown appearance!)

Watch how the movement of the sun alters the way objects look and you are halfway to taking photographs in artificial light or light you direct and control. (With natural light I include existing light sources such as fixed electric lights in houses, or street lamps.) Early morning or evening light is particularly attractive; with long

descriptive shadows, often diffused by mist or slight cloud. Sometimes in winter a few hours before sunset on a clear afternoon you get the stunning effect of a low sun, very bright in the sky, with sharp long shadows glowing with colour. I know several professional photographers who only shoot colour photographs before 10 a.m. or after 4 p.m. At these times the light is warmer in colour (a greater proportion of red and yellow light reaches the earth) and you can record a softness in the highlights with surface textures coming out strongly. This effect also benefits many black-and-white photographs of course.

At midday the sun is overhead casting short harsh shadows. This kills texture on most surfaces and photographs of people show shadows under eyes, nose and chin with little modelling. There is a greater proportion of blue light at this time so the warmer colours disappear until late afternoon. That is no reason to stop looking for photographs at this time. Again, it is a matter of understanding the unique qualities of the light and developing a feeling for the best subject for the effect.

Diffusion

Light changes the way the environment looks according to the angle of the sun in relation to the earth and the position of the camera.

Sunlight is also changed if it passes through cloud or mist or fog. It becomes diffused. Shadows lose their sharp edge or disappear altogether. With the light coming through heavy cloud you are left with just the shapes of the objects and on a really 'dull' day there is no way of knowing where the light is actually coming from. Photographs taken in these conditions rely entirely on the colour or tones of the subject for contrast. Colour transparencies can be spoilt because heavy cloud tends to filter out the warmer colours and give photographs an overall blue 'cast' or appearance. The solution is to use a filter that absorbs the excess blue light (see next chapter). The harsh shadows you see when the sky is clear change the world beyond recognition; the simplest objects are transformed. But remember, exposure is critical in these conditions. The film cannot show detail in the lightest and darkest parts of the subject. You have to choose, and the rules of the game are explained in Chapter IV.

Watch for the light after a rain storm. Light seems to shine out at you from every surface.

This photo was taken in London at dusk.

Artificial Light

Our whole concept of normal lighting is conditioned by the sun. When photographers use artificial light, unless it is for special 'unearthly' effects, the lamps are arranged to produce a believable photograph in the sense that it could have been seen in sunlight.

To take the place of the sun there are two main categories of equipment: electric lamps, of which there are many, many kinds, and flash, of which there are two kinds, electronic and bulb (the the latter using expendable bulbs).

The simplest lights to use with black-and-white film are the more powerful household bulbs (200 watt are the best). These produce a yellow light and since film is not as sensitive to light of this colour and the ASA speed is worked out for average daylight, you must halve the ASA speed.

Photoflood bulbs produce a whiter light, may be used with appropriate colour film and are suitable for black-and-white film provided an extra $\frac{1}{2}$ stop exposure is given. Next up the ladder of lighting sophistication are the tungsten-halogen lamps. These produce a great deal of light, get very hot, require special reflectors and need care in handling. They are compact but more expensive than photofloods—balanced for use with appropriate colour film.

Fluorescent tubes are used in photographic studios, but only for black-and-white work owing to the special nature of the lamp which gives uneven results with colour film. If you ever have to use them with colour film always do a test first using filters recommended in the next chapter. They vary a lot, some simulating daylight, others burning much warmer.

Spot lights use powerful tungsten bulbs mounted behind a lens which focuses the light to a narrow cone; very useful for studio lighting.

Right: a photograph taken in Denmark with back-lighting. Below: a ladies' bowling club in the afternoon sunshine in London.

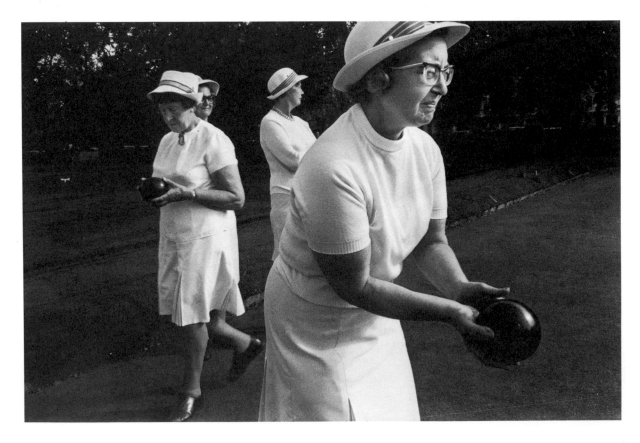

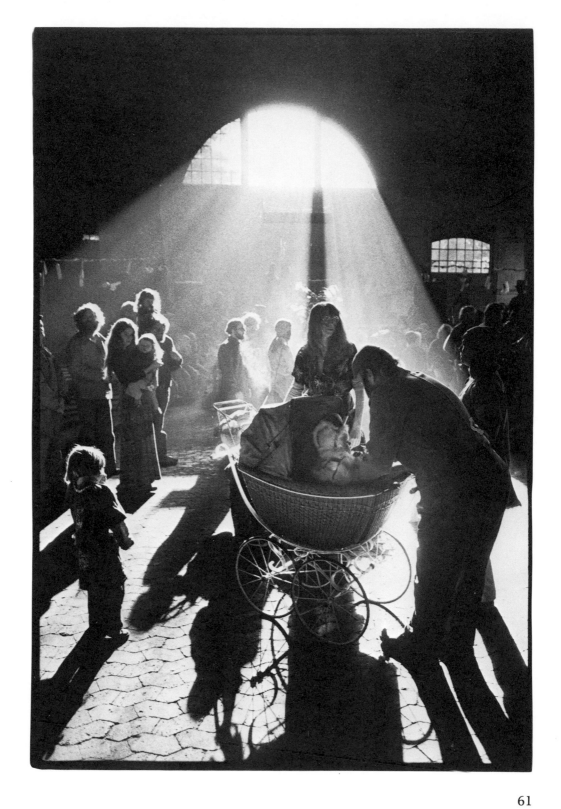

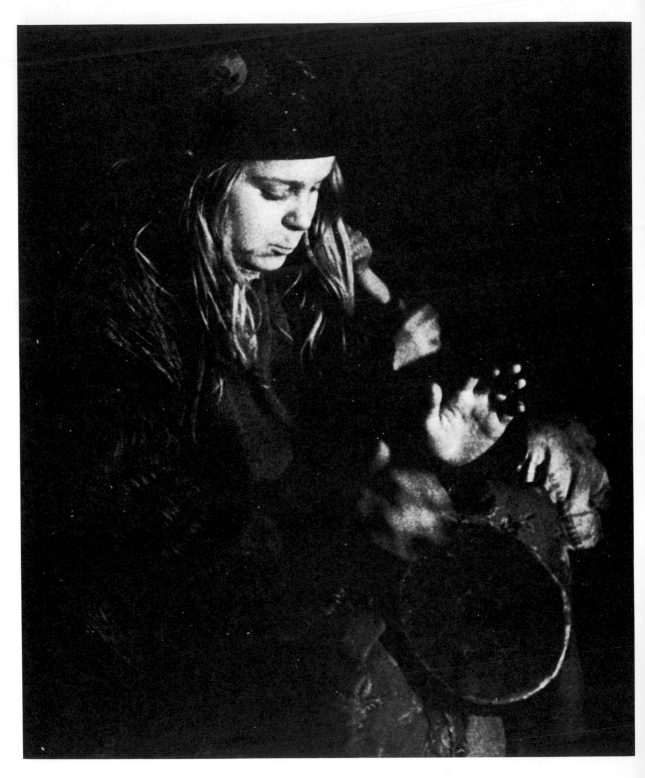

Floodlights produce a wide arc of bright non-directional light. They light subjects without creating harsh shadows.

All these light sources described have one drawback—they have to be used within striking range of mains electricity. Flash equipment bypasses that problem but creates another. You cannot visually inspect the way it lights the subject. Only after the film is processed can you see how successfully it has done its job. Batteries provide the power that operates both systems of flash, although mains electricity may be used with electronic flash.

Flash Bulbs

These are fired by a current pulse from a standard battery. The light is created from the chemical combustion of magnesium ribbon contained within a plastic-coated glass bulb held in front of a reflector which is directed towards the subject. The machine that fires the bulb is extremely simple. It replaced flash powder, used by

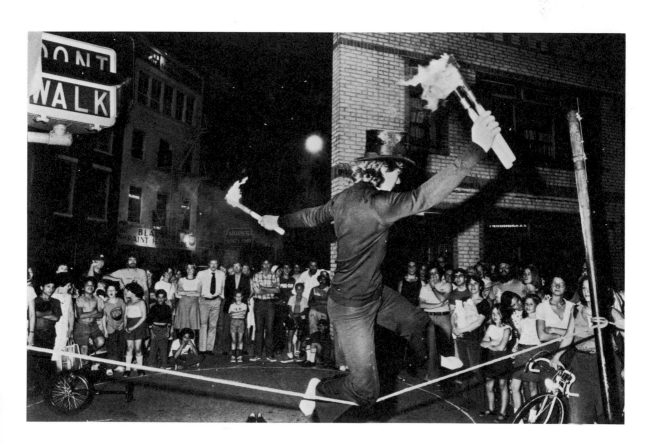

63

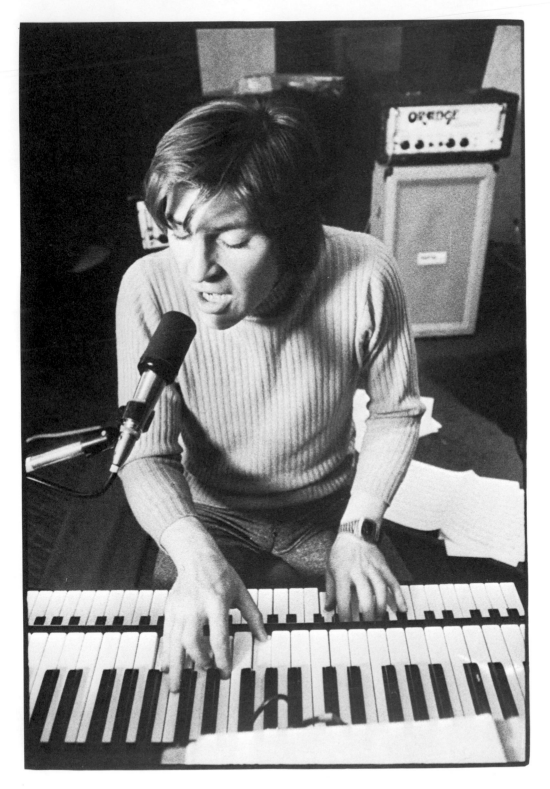

certain early photographers. They would ignite the powder after the shutter had been opened. The powder burned, the shutter was closed, the plate had been exposed. Nowadays the flash bulb is fired by a switch which is incorporated in the shutter. Flash bulbs are expensive and bulky and flash guns are not much cheaper than the cheapest electronic units. Not a good investment.

Electronic Flash

Electronic flash is different altogether. A high-voltage discharge is passed between two terminals in a sealed glass tube containing what photographic books always mysteriously call a 'rare' gas. The light source is the spark that is created the instant the current arrives at either end of the flash tube. The whole operation is over before you can blink—in fact, in as little as 1/10,000 second. The very short exposures possible with electronic flash are an important feature of the equipment. Even the smallest units provide a useful amount of light and are very cheap to run, especially if rechargeable batteries are used.

A recent innovation is an 'electronic eye' which measures the light produced by the flash as it is reflected back to the unit from the subject. When enough light has been received to produce a correctly exposed negative or transparency the flash is switched off automatically. It is a remarkable device since it can measure the intensity of the flash after it has illuminated the subject, allowing it to produce enough light to properly expose the scene. It may curtail the flash to a mere 1/20,000 second, when the flash gun is working near the subject, or allow it to shine for up to 1/400 second when the subject is being lit at the maximum working distance. For most subjects it guarantees correctly exposed pictures and saves the photographer having to work out the exposure mathematically each time. All you do is set the ASA film speed and aperture, and the unit does the rest. Exposure for flash depends on the distance the flash unit is from the subject. The inverse square law states that the intensity of illumination on a surface falls off in an inverse proportion to the square of the distance between them. In effect, the larger the area covered by the flash (determined by the flash-to-subject distance), the less light there is to go around, so the longer the exposures needed. With automatic flash guns the flash continues longer; with manual flash guns you use a larger aperture calculated by dividing the flash-to-subject distance into a published 'guide number'. The electronic eye is fooled by subjects which are

The photo on the left was taken with tungsten floodlights.

65

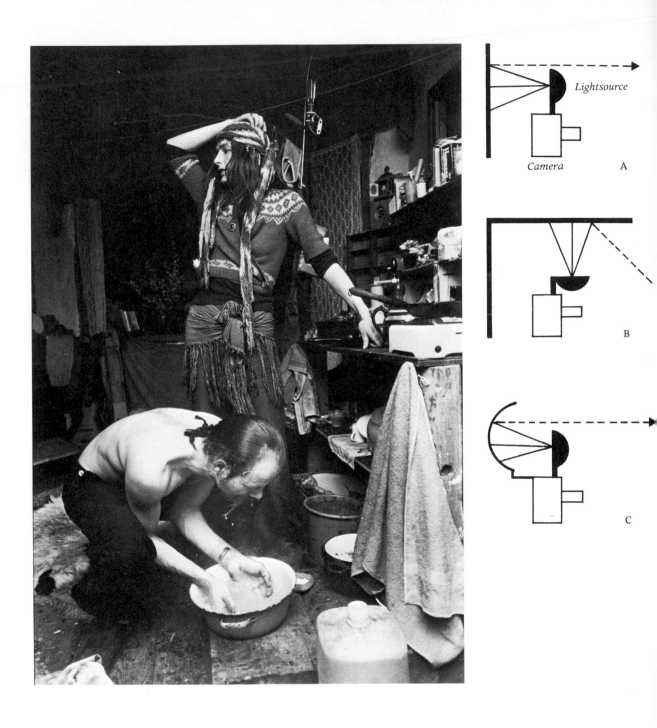

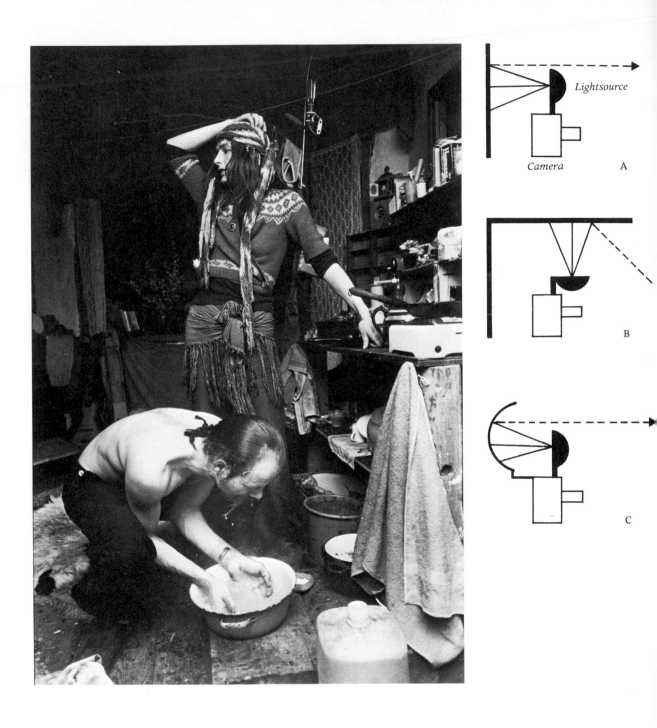

Lightsource

Camera

A

B

C

very light (it underexposes them), or very dark (it overexposes
them). With predominantly light subjects, open the aperture to
allow extra exposure, and with predominantly dark subjects close
the aperture, but bracket exposures. Generally though, the magic
eye works well with direct flash, i.e., flash on the camera directed
straight at the subject. Although photographs taken in this way can
be very effective, the harsh shadows and rapid fall-off are often
inappropriate. The way to get around this problem is to 'bounce' the
light, from either a ceiling or a wall, if one is close enough and not
too dark, or, better, from a reflector attached to the camera and flash
unit.

Bouncing flash from a wall or ceiling gives shadowless light
spread over a large area. At the moment of exposure all movement is
arrested and this effect can produce interesting photographs. But
watch out. Manufacturers exaggerate claims for the power of their
flash guns. Switch to manual and test your equipment in several
different situations; note the results and base further work on these

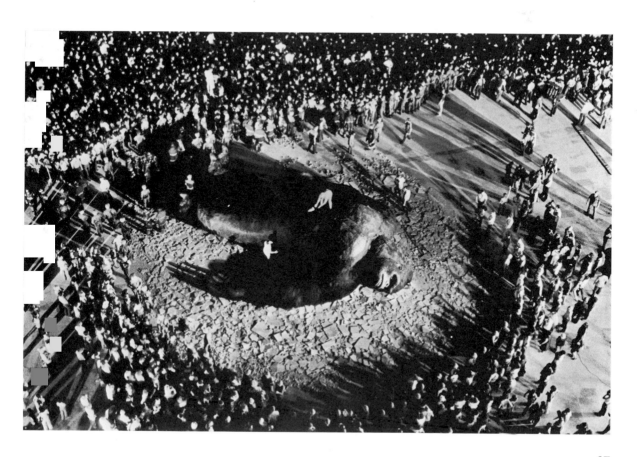

trials. This technique is not suitable for colour unless the walls and ceiling are perfectly white. Any colour in the paintwork will show as an overall cast in the photograph. Colour can be used with reflector-flash-camera units and very beautiful results are possible. Some flash units have a magic eye that can be mounted over the lens and this will enable the correct exposures to be made using a reflector. With manual flash units the instructions give a modified guide number which takes into account the fact that the light is being spread by the reflector to cover a wider arc.

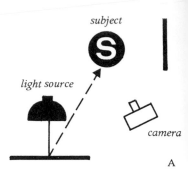

A

Lighting with Lamps

Because daylight is produced by one source of light, the sun, we are conditioned to seeing only one shadow. (There is a place in New York where the sunlight bounces off the side of a white skyscraper which casts a shadow strong enough to compete with the shadow cast by the direct sunshine; the effect of people walking down the street with two shadows in broad daylight is very strange.) The general rule is one main light source casting one shadow. The quality of the light can be changed by bouncing the light off another surface—a wall, a ceiling or a piece of white cardboard placed near the lamp—or by diffusing the light through tissue paper or translucent plastic. As we have seen, bouncing light from a ceiling or wall spreads the light so widely that it appears to have no directional qualities. Bouncing the light from a reflector near the light source softens the shadows leaving details in the highlighted and darker areas. The brightness range (the difference between the lightest and darkest areas) is reduced and more exactly fits the brightness range that film is designed to record.

B

Diffusing the light has a similar effect, and again the closer the diffuser to the light source the more obvious is the effect. It simulates the sun shining through cloud and softens hard-edged shadows and burnt-out highlights.

Of the various light sources mentioned I suggest that the best to experiment with are photoflood lamps used with reflectors. The lamps are inexpensive, lightweight and easy to use. They can be plugged into any mains circuit and are very like household lamps except that they produce light which is balanced for use with the appropriate artificial-colour film or daylight film with an 80B filter (see next chapter). Cheap aluminium reflectors are available with attachments for clamping the lamp to chair backs, or desk tops, etc. They can also be mounted on tripods or special stands.

A good way of becoming familiar with the techniques of lighting

is to photograph friends. I recommend beginning with a session in which you experiment without film, just arranging lights and camera. Select any available friend to model; start with the lamp in the position of the lens and observe the effect as it is moved vertically until it is above the subject's head. Move the lamp through an arc around the lens axis at an angle of 45° to the subject. Use a cardboard reflector in the same positions and notice the different mood it creates. You will undoubtedly find that at a certain point the lighting complements the subject's personality, and the physical and expressive qualities of the face are most accurately revealed. There are no rules in portrait photography—or any other kind of photography for that matter. Sometimes harsh direct light is right, sometimes softer lighting is needed.

When you have established the best position for the camera and main light, consider using a second lamp to give a very much weaker light, perhaps bounced from a nearby wall, as a fill-in. As

Left: two set-ups for lighting.
(a) Light bounced off reflector, with side reflector to soften shadows.
(b) Light shone through diffuser on to subject with side bounced light to give extra highlight and to soften shadows.
Below: shadow effects taken in Romania.

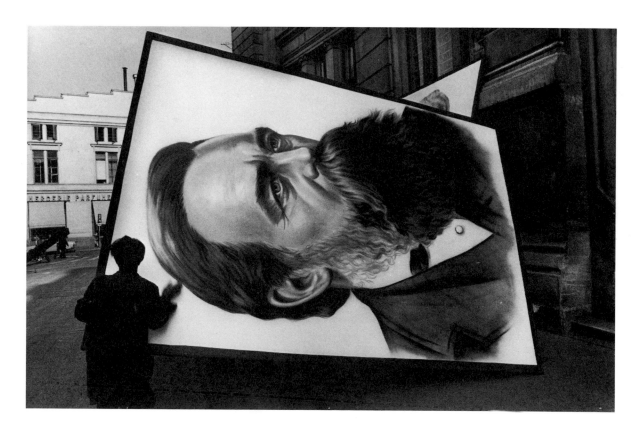

we have already said, the human eye can adjust to a greater brightness range than film. Where you will be able to see detail in the shadow areas, film will record it as a flat dark area. The fill-in light, as the name suggests, adds a little density to the areas not directly illuminated by the main lamp. The overall effect is to reduce the brightness ratio. In fact the main lamp can often be used in conjunction with a reflector to provide a fill-in light by bouncing back some of the light normally lost from the main source. The two most common pitfalls with artificial lighting are to light in too contrasty a manner and to fill in with too much light casting more than one shadow. These will usually be the faults that first disappoint the beginner. Start by providing a somewhat softer light than appears desirable, and always remember that the photographic process increases contrast. Photofloods can also be used to supplement existing available light and I would strongly recommend experimenting with this technique. Window light provides perhaps the most attractive light for portraits; very often no additional light is needed, but when it seems to be necessary a photoflood bounced from a wall or reflector provides just that extra amount of detail in the shadow side of the face to bring the picture really alive.

If you want to show your friend in his or her own environment, experiment until you see a visual harmony between the sitter and the background. In photographs of this nature it is best to try and work with existing light since this is a feature of the environment. If necessary, supplement this with bounced light from the photofloods. This technique can, however, only be used for black-and-white photography.

Filters

Filters are made of coloured transparent material and are supplied with a filter holder that fits over the lens. They are used in black-and-white photographs to produce photographs that more accurately reflect the tonal values present in the original scene, or to distort the tonal values for dramatic effect; and in colour photography to adjust the colour balance of the light for the purpose of matching a particular colour film to a given light source. They are used to eliminate colour casts—usually blue—caused, for example, by heavy cloud or shadow, and also to eliminate unwanted ultra-violet rays rendered as blue. Filters may also be used with colour film to introduce colour casts to the transparency

Photographs combined in a sequence may give a more intensive view of an event than a single picture. This technique extends photographic ability to examine a moment of time. It is an area wide open for experiments.

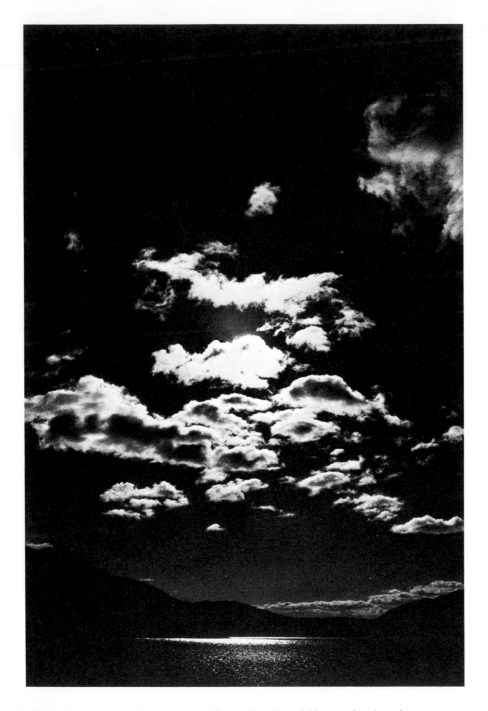

Above: the dramatic effect of a yellow filter and a polaroid filter combined can be used to give a night time effect to pictures taken in daylight. Top right: the effects of a polaroid filter in reducing the reflections on the surface of the water. Below: restoring the surface reflection by rotating the filter to a different position.

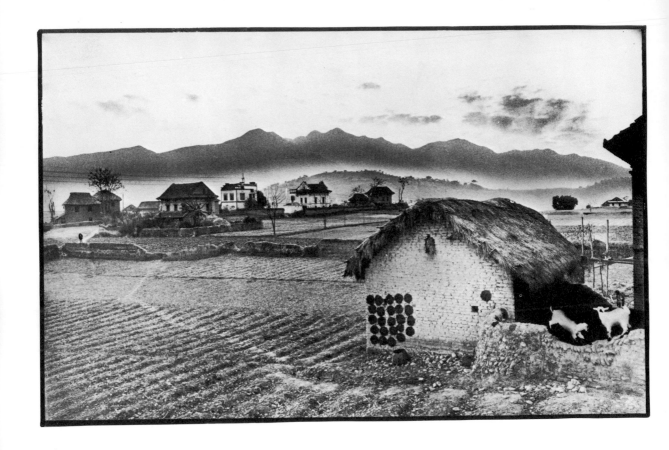

for pictorial effect. There are also special filters for absorbing
unwanted reflections and for producing 'special effects'.

Filters and Black-and-White Film

The guiding principle is that a filter will render similar colours as
lighter tones and complementary colours as darker tones. A red
filter will darken blue sky and green foliage, and lighten red
brickwork. The oversensitivity of black-and-white film to blue
light presents one of the most common photographic problems. Blue
skies will be overexposed and will show as white on the final print
so that white clouds are largely invisible. Yellow, orange and red
filters in that order absorb increasing amounts of blue light,
producing a darker tone to represent blue in the final print. All
filters are graded according to the amount of light they hold back
and the 'filter factor' indicates the amount of exposure increase
required to ensure that the correct exposure is given: a $2 \times$ yellow

Filters can strengthen tone effects in photographs. An ultraviolet filter was used here to help the film 'see through' the haze of this landscape in Nepal.

filter will require twice the exposure, 1 stop, or if you prefer you can divide the ASA number by the filter factor and set the meter accordingly—in this case a 400 ASA film becomes 200 ASA.

Cameras with through-the-lens meters will automatically allow for the extra exposure required, and if you can place the filter completely over the window of the unattached meter a similar adjustment is automatically made. However, the reduction of light allowed for by the exposure meter does not take into account the poor sensitivity of black-and-white film to red or yellow light and it is necessary when using the deeper filters such as orange and red to allow, in the case of a $4 \times$ orange filter, an extra $\frac{1}{2}$ stop and, in the case of a $6 \times$ filter, $1\frac{1}{2}$ stops. Accurate exposure is more important when filters are in use. Underexposure will tend to exaggerate the effects of a filter and overexposure will reduce them. Lens hoods, which should be used anyway, are even more necessary to prevent image degradation when filters are in use.

Filters and Colour Transparency Film

A characteristic of the eye is that it is very tolerant to different types of illumination. A sheet of white paper viewed in the yellow light of a tungsten lamp will appear just as white as when it is viewed in sunlight. Colour transparency film, on the other hand, will record a colour cast where one exists. Daylight is a mixture of 'yellowish' light reflected from the sun, and 'bluish' light reflected from the sky. Photographs taken in shadow, which is illuminated by the bluish sky light, show a blue cast if a suitable filter is not used.

Generally it is better to eliminate too much rather than too little blue. Slightly warm colours are more acceptable. Colour transparency film, 5,500 °K (Kelvin) to 6,400 °K, is manufactured for use in daylight, and both at 3,200 °K and 3,400 °K, for use with artificial light. Conversion filters are available for using all the films with any of the light sources. Colour negative film, because it permits correction of colour balance during printing, has only one problem: that of mixed lighting. For example it is not possible to correct a colour negative portrait exposed to both tungsten light and daylight. The simple solution is not to mix the light sources.

V. How to Develop Perfect
Black-and-White Negatives

The first roll of film I developed on my own I ruined. I had saved enough money to buy a developing tank, thermometer and chemicals. I had read a book on photography and assured the assistant at the photographic shop that I knew all about it. 'Time and temperature, that's what you have to worry about, son,' he said. I went home, borrowed my mum's mixing jug, diluted the chemicals, loaded the film, and developed and fixed it. When I opened the lid I found to my immense disappointment a very badly developed film. I had measured the chemicals in flour ounces instead of fluid ounces.

In fact, developing black-and-white film is really a very simple procedure. The film itself is a long piece of clear plastic with toughened gelatine coated on one side. In this gelatine are suspended many thousands of light-sensitive crystals, which are chemically changed when light touches them. It is a remarkable process. An image is projected on to the film for a fraction of a second and although no visible change occurs in this time the 'latent image' can be made 'real' by immersion in a chemical solution called developer. The crystals that were affected by light energy from the image, i.e., the areas of the subject that reflected light into the lens and on to the film, are converted to black metallic silver by the developer. The objects that reflect very little light to the lens consequently have very little effect on the light-sensitive crystals and become, after processing, the more transparent parts of the negative. However, after development the crystals only slightly affected by light are still light-sensitive. If you were to see the film at this stage you could barely make out the image as it is clogged up by all the unconverted silver. In the final stage of development this unneeded silver compound is removed; this is done by the fixer bath, which changes the still light-sensitive silver compound into a substance that is water-soluble. The final wash eliminates it from the film altogether.

The Equipment

A DEVELOPING TANK—plastic are the cheapest; those that take single cassettes of film cost only a few pounds, but if you want to process more than one film at a time, a Paterson multi-tank may be the answer. Most tanks can be adjusted to process 35 mm, 127 and 120/220 film.

AN OUTDATED FILM to practise loading the spiral.

An easy-to-read CLOCK with second hand.

A PHOTOGRAPHIC THERMOMETER

TWO PLASTIC STORAGE JUGS Especially recommended for developer are the Air-Evac bottles which compress to eliminate air and so extend the life of the developer which oxidizes in the increasing amount of air left in the jug as the developer is used.

A large plastic WASHING-UP BOWL used as a water jacket to maintain processing solutions at the correct working temperature

A MEASURING JUG and MIXING STICK for diluting and mixing the processing chemicals

A CHANGING BAG for loading film into the developing tank if no completely dark room is available. This can of course be done at night in the cupboard under the stairs or any other room shielded from artificial lights.

SCISSORS

BEER–CAN OPENER

The Chemicals

DEVELOPER is available as a powder, the cheapest way of buying it, or as a concentrated liquid. These are two of the standard brand names: D76, 1D11.

FIXER is most economically purchased as a powder. There is little or no difference between brands. Rapid fixer is available as a concentrated liquid.

WETTING AGENT A few drops in the tank after washing ensure even drying without scum marks. Paterson's brand incorporates an antistatic agent which helps prevent dust drying on to the film.

Preliminaries

Loading film into a developing tank for the first time can be a traumatic experience. The purpose of the tank is to hold the film in a conveniently shaped frame that enables the processing solutions to circulate to all parts of the film. The spiral or reel is then placed in a light-tight box that allows the solutions to be poured in and out in daylight without letting light reach the developing film.

With most makes of plastic spirals the film is fed from the circumference towards the centre. The technique can be learnt very quickly. Practise in the light with the outdated film following the

In Darkness

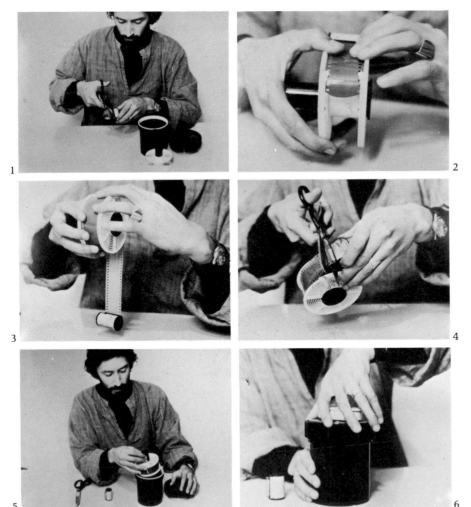

Developing film (we have marked the daylight and darkness sections)

1. Cut the leader tongue off the film.

2. Thread the film into the open grooves of the spiral.

3. 'Walk' the film on to the spiral.

4. Cut the end of the film from the cassette.

5. Place the loaded spiral in the tank.

6. Screw the tank lid on and turn on the light.

78

By daylight

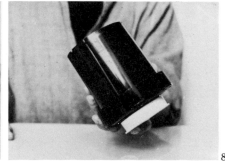
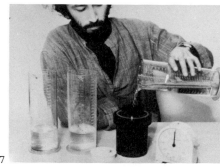

7

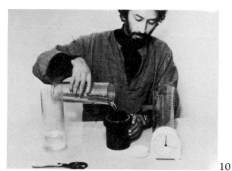
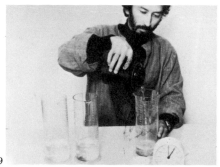

8

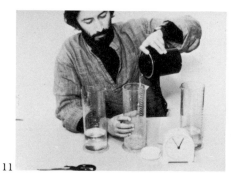
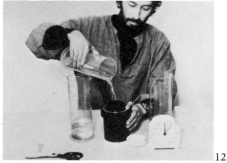

9

10

7. *Prepare chemicals and check temperature, pour in developer and start timer.*

8. *Agitate by inverting tank once every 5 seconds for the first 30 seconds and then for 5 seconds once every 30 seconds.*

9. *10 seconds before the timer indicates the end of development pour developer out of tank.*

10. *Add stop bath or water rinse and agitate for 30 seconds.*

11. *Empty stop bath from tank.*

12. *pour in last chemical—the fixer; agitate for the first 30 seconds then for 5 seconds every 30 seconds.*

13. *After fixing is complete return the fixer to the storage bottle until exhausted.*

14. *Wash the film—30 minutes in summer, 60 minutes in winter; hang film up to dry in dust-free room.*

11

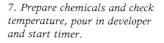

12

13

14

manufacturer's instructions. Design differences between brands require slightly different techniques but the principles are the same.

Loading 35 mm Film

Make sure all parts of the tank are placed in the changing bag; try not to wind the leader of the film back into the cassette. Cut as shown in the photograph and push the film a few inches into the spiral grooves. These first few centimetres of film are fogged when the cassette is loaded into the camera so no pictures will be lost. Now 'walk' the film into the spiral and carefully tear the film from the cassette when you come to the end. If, when you rewound the film, you pulled the leader tongue back into the cassette, you have to lever the cassette top off with a beer-can opener, pull out of the cassette the plastic core that the film is wrapped around, cut the leader off square, as shown, and load into the cassette, all in the dark. The adhesive tape holding the end of the film to the plastic core may generate sufficient static electricity, if torn, to expose the last frame, so it is better to cut with scissors. After loading, push the spiral fully on to the centre column and place in the tank. Carefully screw the lid in place and when you feel satisfied that the tank and lid are correctly joined they may be removed to daylight.

Loading 120 Film

In the dark room unroll the film from the paper backing, clip corners of the film to enable easy loading into the spiral and 'walk' film into reel, following the instructions for 35 mm.

Film Handling

The emulsion side of the film is easily marked. Both pressure and light cause the film to darken. It is also very absorbent, so damp hands will leave finger prints. The back of the film can be gently touched with dry clean hands. If you are not sure in the dark which side is which, put the edge of the film to your lips. The absorbent emulsion will stick lightly to your mouth.

If you follow the instructions that come with the tank and have a few practise runs at loading, you will soon feel confident that you can do a very professional job.

Processing

The film and developer combination I am familiar with is Kodak's D76 and TRI-X. D76 is a cheap, simple-formula powder developer

similar, if not identical, to many other brands available. Development times given are for Kodak films, though an accurate guide for processing other manufacturers' films is to give the same time and temperature combination for an identically rated ASA film; for example, Ilford HP5, 400 ASA film would be given the same time as Kodak TRI-X, 400 ASA film.

Follow the mixing instructions that come with the developer and allow it to stand for 24 hours before use. This solution is called the stock solution. It should be diluted one part stock solution to one part water just before use. Here is a trick for getting the developer easily to the correct temperature. If your tank takes 300 ml of solution, mix 150 ml of developer into a measuring cylinder. Take its temperature. Suppose it is 14 °C and the required development temperature is 20 °C—the water you dilute it with should be 26 °C.

The Fixer

The cheapest practical way is to buy regular acid-hardening fixer. Dilute according to instructions and measure the correct quantity at 20 °C needed to cover the film in your processing tank. Prepare the same quantity of developer, again at 20 °C. Both solutions should be in clearly labelled jugs and a third, filled with water at the processing temperature, should also be placed in the washing-up bowl where a larger volume of water at 20 °C maintains processing temperatures. Check with the developing tables the correct processing time. Most developers can be used at a number of temperatures, and different times are published; make sure you look down the appropriate column. Developing times are sometimes given for two types of enlarger: diffuser enlargers require more contrasty negatives so development times are longer; condenser enlargers are the most usual. If in doubt refer to the enlarger manual.

Developing

Set the clock and pour the developer into the tank. Tap the tank lightly on a bench to dislodge air bubbles and with the plastic cap in place invert the tank and return to an upright position within 5 seconds. Continue this action for the first 30 seconds, then one inversion every 30 seconds. This ensures even development with fresh developer circulating throughout the length of the film. Fifteen seconds before the development is complete, pour out the developer (it cannot be re-used), pour in the water and agitate for 30 seconds. Empty the tank and pour in the fixer. Agitate for the first

30 seconds and thereafter an inversion every 30 seconds for the specified time. Fixer can be re-used. You have now developed the film! All that is required is to wash and dry it. Try to resist the almost overwhelming temptation to unwind the film from the spiral and see if it has come out. It is very soft and easy to damage and it is hard to stop unwinding once you start. The best way to wash the film is to take the top off the tank, having poured the fixer back into its bottle, and use a force film washer connected to the *cold* tap. In summer wash for 30 minutes, in winter with colder temperatures wash for 1 hour. At the end of the wash, with water still covering the film, put in a few drops of wetting agent and leave for 30 seconds. Then carefully take the film from the spiral. Arch the free end by bending the two edges together slightly, then pull gently on the free end and allow the spiral to rotate. A string hung across the bath with spring clothes pegs allows the film to be dried in dust-free conditions.

Wash the tank lid and cap and all the equipment used (the spiral and tank body will be clean after the film wash). Wipe up chemical spills and dry surplus water from all items, especially the spiral. If this is not perfectly dry film will not load properly.

Some Background Information

A few basic facts and hints will help you to avoid mistakes. It is important to understand that the developer would continue to build up density on the film well beyond the level needed to make good-quality prints. The length of time needed to produce the best negative is largely influenced by the temperature of the solution. So both the time and the temperature are critical. Take every precaution to ensure that correct measurement of these factors is achieved. In bread baking the temperature of the oven and the time the dough is in the oven are important in the same way. Unlike developer, the fixer, once it has done its job, stops, so time and temperature are not quite so critical.

Some developer inevitably will carry over into the fixer, but every precaution must be taken to prevent fixer mixing with the developer; if this happens, discard the developer. Once the negatives have been washed they must not be allowed to come into contact with any chemicals. Always handle by the edges and store in negative storage sheets.

Manufacturers' development times (and or ASA settings) may not suit your equipment. If you find your negatives are consistently

Developing faults and their causes

A *A negative with this appearance will have been correctly developed but under-exposed. The contrast is normal but there is little density in the shadow areas and the whole negative lacks density. The printing of under-exposed negatives is difficult—almost invisible scratches appear on the print—but if you use harder paper the result can be acceptable.*

B *The negative has been correctly developed but over-exposed. the definition is soft, the highlights have been burnt out and the overall appearance is very dark. Prints have a muddy, grainy appearance, showing poor separation between the tones.*

C *Correctly exposed and correctly developed—showing detail in the shadows and highlights. A negative easy to print on normal-grade paper.*

D *Correctly exposed but under-developed. The negative is flat, lacking contrast, with little separation between the darkest and lightest parts of the picture. Printing on hard contrasty paper will help to produce a normal-looking print.*

E *Correctly exposed but over-developed, producing a very contrasty negative with dense blacks. It can be printed on soft paper to produce a soft print.*

F *A print made from the correctly exposed negative C.*

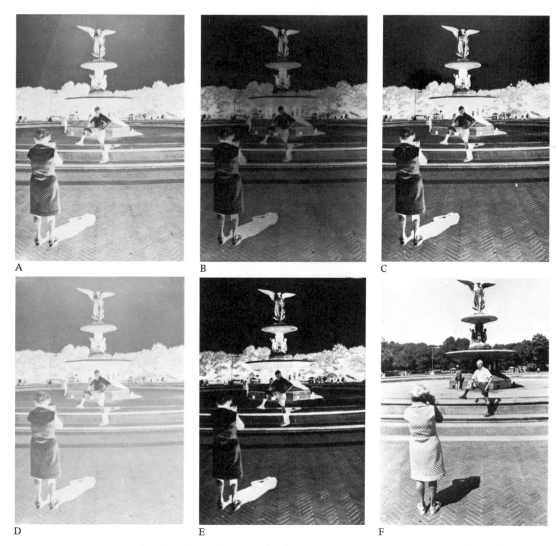

A B C

D E F

underdeveloped, i.e., lacking in contrast, increase development time by one minute. If you find the negatives are too contrasty, reduce development time by half a minute until you are satisfied with the results. Contrast is explained fully in Chapter III. You may also find you get better results by using a lower ASA setting and thereby increasing exposure. If you use a 400 ASA film and the negatives are rather thin and show scratches and dust when printed, try rating it at 320 ASA. In general terms exposure controls density and development controls contrast.

When your film is dry examine the negatives. The faults can suggest alternative techniques. If the film was overdeveloped it will be dense and contrasty. If this happens to negatives exposed in

normal conditions it may be difficult to make good-quality prints from them. If you have been shooting in dull, flat light and want to boost the contrast, it is perfectly acceptable to reduce the exposure time by half, rating a 400 ASA film at 800 ASA to compensate for the extra density that the prolonged development gives the film. In this case I suggest increasing the development time by 25 per cent. If you are using a slow film in very contrasty light, you can overexpose and underdevelop. Plus-X rated at 64 ASA instead of 125 ASA would be processed for 15 per cent less than the published development time. This makes for softer negatives which are easier to print. (This technique is not usually applied to faster films which are better able to handle contrasty subjects.)

The purpose of correctly exposing the film as explained in Chapter III was to make negatives that will easily produce first-class prints. With some understanding of the effects of processing, it is now possible for you to stretch the usual techniques and obtain even better results. Chapter VI explains how contrast affects the print. Once you understand this you will easily be able to put this advice into practice. Remember though, the whole film must be exposed at the same ASA rating. With a little experience you will soon learn what 'normal' means in photographic language. This will give you a standard by which to measure your experiments. The times I have suggested are simply a guide. They suit my work done on my equipment. Experiment and keep records of the results. The aim is to be able to take photographs in as many different conditions as possible.

Contact prints should always be stored next to the negative. This will make it easier to find any photographs you want to print.

VI. Printing

Not much pleasure is to be had from looking at the tiny 35 mm or $2\frac{1}{4}$ in (6 cm) square negatives, but you are now only a couple of steps away from the finished print. First 'contact prints' must be made of all the films. By now these should have been cut into strips, six negatives long in the case of 35 mm film and three negatives long in the case of $2\frac{1}{4}$ in (6 cm) square film, and stored in negative storage sheets which accommodate an entire film with each strip in its own compartment. This avoids damage caused by negatives rubbing against each other, and helps to keep dust away. Contact sheets show a print of each picture in exactly the same size as the negative. They are useful for two reasons: firstly they simplify the job of editing, and secondly they help locate particular films.

So from the contact sheets select the negatives to be enlarged. Watching an image gradually form on a piece of enlarging paper is one of the most rewarding and pleasurable experiences I know. There is a magic about it that somehow never loses its flavour. This part of the procedure takes place in a room illuminated with orange or amber lights, to which the printing paper is not sensitive. The following equipment is needed for contact printing and enlarging.

Developing Equipment

SAFE LIGHTS The cheapest are orange-coloured bulbs that plug straight into ordinary household sockets; these are available in photographic shops.

THREE PLASTIC DISHES for processing the paper in. They need to be slightly larger than the largest size of paper you intend printing on. You will anyway need dishes capable of making 25·4 cm × 20·3 cm (10 in × 8 in) prints, as this is the size used for contact prints. For the time being, taking into account the cost of paper and developer, this size will probably be large enough.

The WASHING-UP BOWL used as a water jacket when you developed the film can now be used as a hand rinse if there is no running water in the room.

THERMOMETER, MEASURING CYLINDER AND TIMER with a second hand—all items you will probably have bought for developing film.

A SHEET OF $\frac{1}{4}$ IN PLATE GLASS 11 IN × 9 IN with well-rounded corners to sandwich the negatives and printing paper together and allow exposure to be made.

PRINT TONGS These grip the print and allow the photographer to move it from one dish to another without wetting his hand. Optional unless you have sensitive skin.

SIPHON UNIT for circulating the water around the prints at the washing stage

ENLARGER This is not strictly necessary for making contact sheets, but is useful because it provides even illumination. Its primary function is to project an image from the negative on to the enlarging paper. A special light bulb at the top of the enlarger shines through a condenser or diffuser, which spreads the light evenly towards the negative holder. This, as the name implies, holds the film flat and still while the exposure is made. A lens mounted so that it can move towards or away from the negative focuses the image sharply on the masking frame which holds the paper flat and still. The enlarger head may be moved up or down the column until the correct image size is found.

If you can buy a secondhand enlarger, check particularly that the focusing movement is smooth, that the enlarger head locks into position anywhere on the column, and that the bellows are not torn. Diffusers are not suitable for 35 mm work and are usually found on very cheap enlargers or enlargers designed for very large negative

Timer, thermometer, three dishes and tongs on wet bench.

Enlarger and dry bench with easel and paper. Wiring and negatives must be kept away from chemicals.

A darkroom can be set up anywhere where no unwanted light may intrude. This darkroom is temporarily set up in part of a kitchen.

86

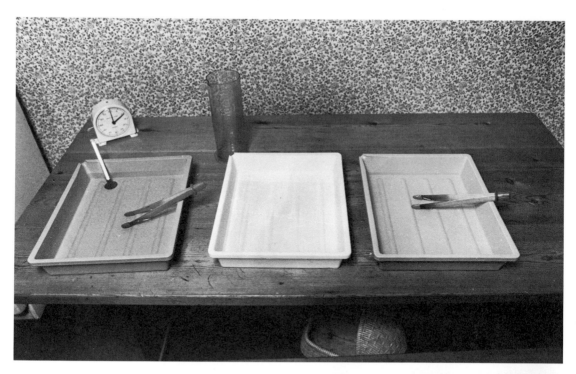

sizes. Check the lens for scratches, and make sure it is coated (that bluish tint seen when the lens is held to the light improves the clarity of the image). Enlargers wear out more gracefully than cameras and a secondhand one, carefully chosen, should give good service.

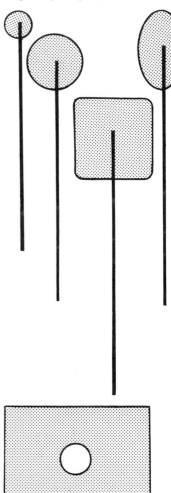

Diagram of 'dodgers' and mask.

ENLARGING EASEL This holds the paper flat and still throughout the exposure, provides a white surface on which to size up the image and usually has a way of adjusting the white border around the print area. This is an item that can be made quite easily with a piece of sheet steel covered with white adhesive plastic on top with $\frac{1}{8}$ in foam rubber glued underneath to prevent it sliding on the enlarger base board. You will also need four button magnets and four corks. Glue the corks to the magnets, drive needles through the corks until the point touches the top of the metal sheet when the magnets are placed on it. Draw lines showing the popular paper sizes and after positioning the paper use the needles at the extreme edges to hold each corner in place. The only disadvantage with this is that no border can be made, though you could cut a cardboard mask and place it over the enlarging paper with the needles holding the mask and paper to the easel.

DODGERS These are easily made from wire and cardboard. The basic shapes are those illustrated, but it is often necessary to make one to specially suit a difficult negative.

MASKS Just a piece of cardboard with a hole pressed in it. The function of these items is explained later in the chapter.

THE TEMPORARY DARKROOM This is best situated in the kitchen rather than the bathroom where there are problems of wiring the extra electrical equipment into nonexistent sockets or, worse, squeezing everything into a plug designed for an electric razor. The enlarger should be earthed and fitted with a suitable and easy-to-reach switch, and should definitely be set on a separate table away from the wet bench and running water. Electricity and water do not mix. No trailing electric cables should be allowed on the floor or anywhere near any of the solutions. Switches should only be handled by dry hands. If the enlarger was bought secondhand, make sure the cable is not worn—if it is, ask an electrician to rewire it.

A blackout hardboard panel with a wood batten nailed around its edge. A foam strip should be glued around the frame to allow for a tight fitting, and a handle can be attached to the centre of the panel.

For a work table a blockboard should be covered with heavy-duty, self-adhesive plastic. A wooden frame around the edge will stop chemicals dripping on the floor. Allow enough space for three developing dishes and a washing bowl.

BLACKOUT If printing can be done in the evening then in winter no special blackout materials will be needed. The curtain already in place should keep out any unwanted artificial light. Summer evenings take a long time to darken up and a simple blackout screen should be made to fit over the window frame. This easy-to-make unit will keep out enough light to print during the day, all year round. If necessary, a heavy rug can be hung over leaky doors.

WORK TABLES You will need two separate tables. One takes the enlarger and boxes of paper and is referred to as the dry bench. The other, wet bench, takes the processing dishes and washing-up bowl and needs to be plastic-covered. This does not need to be elaborate. I use a sheet of blockboard covered with self-adhesive plastic, which has lasted so far for four years. If there is no table large enough or with a suitable top, you might consider making a table top that would fit over an existing smaller table and would have the advantage of stopping chemicals dripping on to the floor (see diagram).

Enlarging papers

There are many brands available in the USA but only three in Britain. Prices vary only slightly and although each brand does have its own characteristics, now that Agfa paper is being discontinued, the days when really substantial differences in the quality could be seen have gone. Tests I have made do not indicate an important enough difference to recommend one brand rather than another.

There are two basic emulsions used: bromide papers, characterized by exceptionally white paper base and an emulsion that gives a rich neutral black; and chlorobromide papers, giving warmer blacks and a long tonal range. The colour of the image can be altered by special developers, some producing almost a sepia tone on chlorobromide paper. Unfortunately there is no quick way to research all the variations, nor is there space in this book to go into the nuances of the more subtle effects of printing. Information of this kind can be obtained from the manufacturers of photographic papers and chemicals. Both types of emulsion are available in a number of surfaces: glossy for maximum brightness range, and good for showing fine detail—a beautiful paper when left unglazed; smooth lustre, without texture but lacking the high sheen of glossy paper; semi-matt, a fine texture but still showing minute detail; fine

89

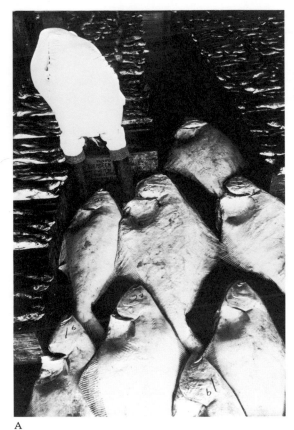

A

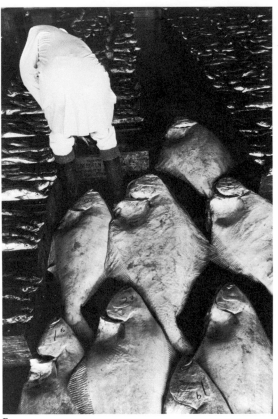

B

lustre, a fine-grained texture with a slight sheen; fine pearl, described by Kodak as a 'low-lustre paper'—useful occasionally for prints that require a lot of retouching.

The textured papers reflect a limited range of tones compared with glossy papers. The choice is a personal one; and shops usually have a booklet of specimen surfaces, which also show the base tint. Apart from white you can get ivory or cream—to my mind guaranteed to spoil any photograph. Four thicknesses of paper are available, airmail, light-weight, single-weight and double-weight. 'Resin-coated' papers are manufactured to a thickness midway between single and double weight. Double-weight paper is required for larger sized prints as it is easier to handle. Single-weight papers pick up crinkles easily, are more likely to get damaged, and need more care in drying. The relatively new resin-coated papers are coated to prevent the absorption of chemicals and to allow quick washing (5

A *A normal negative printed on hard paper shows burnt-out whites and shadow areas lacking in detail. It is uncomfortable to view.*

B *A print made on normal paper shows detail throughout the tonal scale without being too contrasty or soft.*

C *Soft paper will show clogged-up shadows and highlights and is unpleasant to view.*

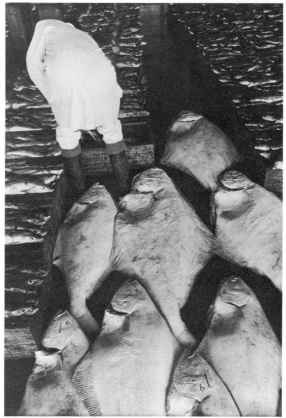

C

minutes instead of 30 to 45 for double-weight) and rapid drying. When air dried they can be flattened more easily than standard prints and, though thinner than double-weight, feel almost as strong. They are more expensive than standard papers and are not available in as many surfaces; and they have a slight milkiness which never quite disappears so that their maximum black is not as deep. Also the surface of resin-coated paper is more easily scratched than fibre-based papers, but since many professional users have switched to it a great deal of research is being done into ways of improving it.

CONTRAST GRADES These are not a fancy trick to distract photographers with; like paper tints and textured surfaces, they are an essential control necessary for making fine prints. All the papers described are manufactured in three or more contrast grades. The full range is labelled from 0 to 5, though Kodak Grade 2 will not be the same as Ilford Grade 2. However, the lower the number the

A

B

'softer' the paper. 'Normal' is designated Grade 2 and hard papers are Grades 3, 4 and 5. I think the easiest way to explain these rather nebulous terms is to say that the 'soft, paper grades' 0 and 1, respond mainly in tones of grey, particularly the mid-tones, and produce a dense black or perfect white only if the negative is perfectly clear or opaque. 'Soft' papers will produce 'normal' prints when a 'contrasty' negative is used, i.e., a negative that has compressed tones to the extremes of light and dark and is short on mid-greys. The 'soft' paper then emphasizes the mid-tones captured in the negative, giving a more balanced print. A negative which is 'soft', perhaps because of being underdeveloped or exposed in very soft light, and which on normal paper produces a rather flat print lacking sparkle and depth, with poor separation of the different tonal values, will be vastly improved by printing on a hard grade of paper. 'Hard' paper translates the dark greys into a better defined

A *A contrasty or hard negative printed on hard paper produces a print almost without mid-greys—everything is reduced to black or white.*

B *On normal paper the print appears still too contrasty but the mid-greys are beginning to show.*

C *Soft paper gives a print with a full tonal scale, with enough contrast to give the picture bite and without the burnt-out appearance of the other two prints. Detail can be seen in all parts of the picture.*

C

black, shows more detail in the darker tones, and by compressing the tonal scale produces well spaced tones and clearer whites. A negative of 'normal' contrast will print naturally on a normal grade of paper, reflect as accurately as possible the tones in the original scene and be satisfying to the eye—but no more so than a print made on a 'hard' paper from a 'soft' negative. It is a question of matching paper and negative. Contrasty or flat negatives print as simply as normal ones, and look as natural, on the right paper.

As you may have realized from the subjective language used to describe contrast grades, an aesthetic judgement is involved. Many photographers during the last fifteen years have preferred to match their negatives to a slightly harder than necessary paper which tends to give an extra sparkle to their photographs and perhaps a more graphic quality. Previously prints were made on the softest paper one could get away with.

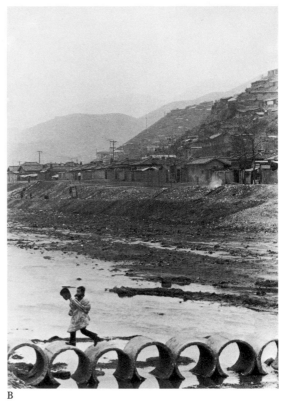

A

B

It is a combination of all these variables, technical as well as pictorial, that makes for style. To start with, you just have to tread carefully through the jungle of possibilities. The speed or sensitivity of the paper grades is claimed to be the same (with the exception of Kodak's Grade 4 which is half the speed). A visual way of understanding this problem of contrast is by turning on the television when the test card is being broadcast, and adjusting the contrast control to see the change in the tones; then experiment in the darkroom.

Chemicals

DEVELOPER Any standard print developer will do—cheapest when bought in powder form.

FIXER Use the same substance as for processing films but more dilute.

A *A soft negative printed on hard paper produces a print with a normal tonal scale and good separation between the tones, naturally resembling the original scene.*

B *On normal paper it produces a print with little contrast, which is unattractive to look at.*

On soft paper with reduced tonal scale without perfect whites or blacks, a muddy, clogged-up print. This photo was taken in South Korea.

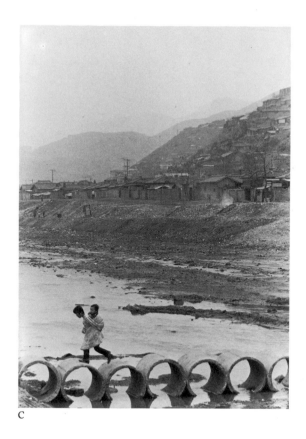

C

Making the Contact Print

Mix the chemicals to working strength at 20 °C: developer in the first dish, water in the second and fixer in the third. Fill the washing-up bowl with warm water for rinsing hands in at the end of a run, and turn the white light off and the safe light on.

Exposure

This is determined by a controlled trial and error—what photographers call a 'test strip'. This is my version: open a 10 in × 8 in (25·4 cm × 20·3 cm) packet of normal paper, remove one sheet, tear into four pieces and return three to the pack. *Handle photographic paper only with clean dry hands.* Select two or three strips of negatives from the first film you intend to contact print.

95

These strips should be representative of the density of the film
about to be printed. Sandwich them between the glass and paper on
the enlarger baseboard. With glossy paper the shiny side is the
emulsion side—this should be in contact with the matt side (i.e.,
also the emulsion side) of the film. Raise the enlarger head high
enough to illuminate the entire sheet of glass which is placed under
the lens. The enlarger is now being used simply as a source of
illumination. The *f* stop dial on the enlarger lens works in the same
way as the dial on the camera lens. Close down 2 stops—you can
feel it click at each division. Set the clock to zero and turn the
enlarger on. Expose the whole sheet for 5 carefully timed seconds.
Turn the enlarger off and hold a piece of cardboard over a third of
the enlarging paper, about half an inch above the glass in order to
cast a well defined shadow. The card must be held still during

96

exposure. Now expose the remaining two-thirds of the test strip for another 5 seconds. Again, turn the enlarger off and move the card along so that only one-third of the paper can receive exposure. Turn the enlarger on for 10 seconds—and then off. The result is that the first strip has been given a total of 5 seconds, the middle strip 10 seconds and the last piece a total of 20 seconds. Now exceptionally light or dark negatives might not fit into this range of exposures, but most negatives will and if you come up against films that require less than 5 seconds close the lens down one or more stops—it is difficult to time less than 5 seconds accurately. If the 20-second sector of the test strip does not produce enough exposure, open the lens by one or more stops and or give a longer time. Always double the exposure—40 seconds next and so on.

Developing

Set the timer to zero, put the paper, emulsion side down, into the developer in one quick movement, wetting the entire emulsion surface without hesitation. Now turn the paper over and watch the magic. It is more impressive when you get to the real print but this is pretty good. After about twenty seconds a faint image appears—it grows stronger and stronger until development more or less stops after about one and a half minutes. Gentle agitation is the rule for print developing, and after 2 minutes take the print out of the developer and put it into the water for a quick rinse on its way to the fixer. Again gentle agitation for about one minute and you can safely turn the light on (assuming the fixer is reasonably fresh—allow more time for a used solution and keep a check on the amount of paper you put through the solution; discard according to instructions). You will clearly see which is the best exposure—if 10 seconds is too light and 20 seconds too dark, expose for 15 seconds. Having decided the exposure, place all the negative strips the same way round on the printing paper, expose for the time indicated by the strip, and develop as described.

When the prints have been in the fix for the correct time (consult instructions as this varies from brand to brand), move them to a sink and replace the plug with a washing device. I suggest a length of rubber tubing that connects to the tap and carries water to the bottom of the sink, so that the water has to flow past the prints before running into the overflow, taking the fixer with it.

Resin-coated paper needs only a 5 minute wash, single-weight paper 30 minutes, double-weight paper 45 minutes—all times based on the 20 °C water temperature.

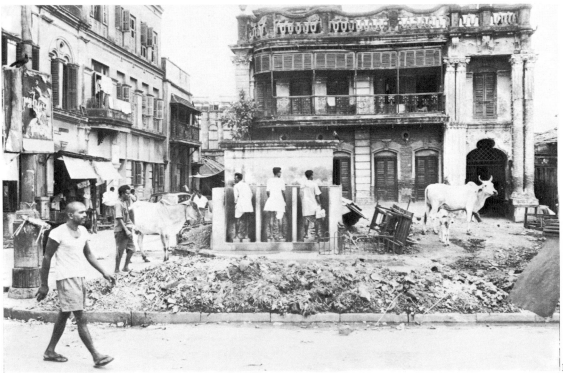

A *After 30 seconds the image emerges.* B *After 60 seconds, looking more like the real thing.*

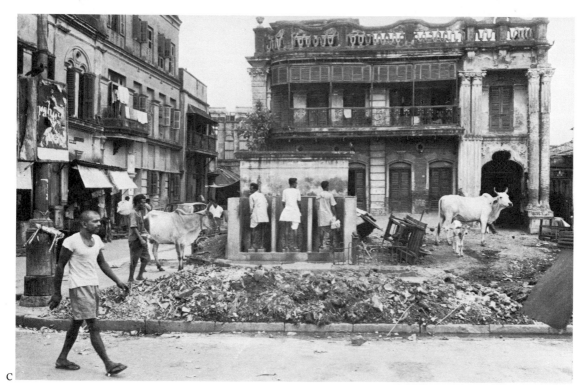

C

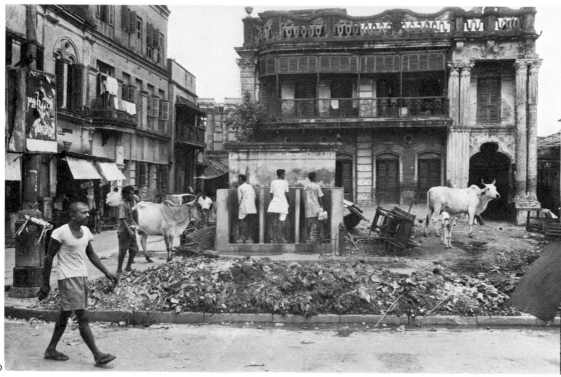

D

C *Two minutes—fully developed with all the tones in correct relation to each other.* D *Four minutes—the extra development will increase the density and contrast slightly.*

Drying

Once the prints are washed they can be dried most easily in a print drier. Caution is needed when using print driers because fixer will migrate from an incompletely washed print and transfer to the drying cloth, which will spoil prints subsequently dried there. Make sure the thermostat is adjusted correctly for resin-coated paper, which will melt and stick forever to the drying cloth at temperatures normal for standard paper. A less commercial way is to construct frames and stretch fibreglass screens across them. Lay the prints on them, face down if you used standard paper, face up if you used resin-coated paper, having first removed the water with a rubber squeegee (the best are the inexpensive ones used for window cleaning), and leave to air dry. This takes very little time for resin-coated papers which dry almost flat. It may take all night for double-weight paper and I do not advise drying single-weight papers in this way as they tend to curl badly.

Enlarging

You will find the selection of the pictures you want to enlarge much easier from dry contact sheets, so I suggest two sessions in the darkroom, the first to contact print all the films you have waiting to be printed; then, having made the selection, take the next opportunity to print them. Selection takes time. It is an opportunity to look at pictures that have not worked. There are lessons to be learnt from those photographs and they are worth your attention if not your expensive printing paper.

Mark the contact prints you want to enlarge with a blue chinagraph pencil, which stands out in the orange safe lights. It is worth buying a good magnifying glass to make sure you are picking out the best ones. Now, finally, you are ready to make the big print.

Put the chosen negative into the enlarger, shiny side up, emulsion side down, and size and focus the image to fit the paper. Focus, by the way, on a piece of scrap enlarging paper of the same weight as you intend to use, with the lens set to the largest aperture—it is easier to see the image and focusing is more critical before the lens is stopped down. (If I may digress for a moment, you can observe depth of field at work. Open the lens and throw the image slightly out of focus. Now stop down slowly and see how the image becomes increasingly sharp. This is exactly what happens in the camera lens and may help you remember principles written about in Chapter IV.)

When the image is sharp, stop down three times (you can do this by feeling the click at each division). At this setting you will get

This test print shows different exposures of the most important part of the picture, in this case the face.

maximum sharpness from your lens, with most exposures falling between 5 and 20 seconds. Although the exposure for each film was found by test strips, the results from these will not help in determining the exposure for individual negatives. A test strip must be made from each negative, though in time you may be able to look at the image on the baseboard and guess the right exposure. Until then you will waste time and paper if you do not follow the rules, and remember you have to be accurate to within one second in ten, so do not be in a hurry to dispense with the test strip.

This time take the quarter sheet of paper, put it on the baseboard over an important area of the picture—for example, a face or a prominent building—and expose in the way already described. Your enlarger may have a red filter; this helps locate the best part of the picture to test, as you can leave the enlarger switched on with the filter over the lens until the paper is in position. Now set the clock to zero, switch the enlarger on without the red filter in place, and carefully time 5 seconds. As before, cover one-third with card held near but not touching the paper. It is most important, if the test strip is to be of use, to ensure that the divisions between these three strips are well defined. If they are blurred the test strip is almost useless. Finish making the test strip, process fully and fix.

With the white light on assess the exposure, remembering that prints dry slightly darker and with less sparkle, unless you use resin-coated papers, which change very little. Expose the whole sheet of paper and develop for the same time and in the same way as the test strip. Resist the temptation to pull the print out early because it looks too dark in the dim safe light. Just enjoy a unique moment and reserve judgement until you are able to turn the white light on. If you take the print out of the developer prematurely, the image will have a greenish cast and lack sparkle. Full development is needed before the tones really come to life, so let the exposure control the density. There will almost certainly be improvements that can be made, so look with a critical eye and check these points:

A *This photograph was taken in very uneven light, with direct sun on the Indian woman and indirect light on her daughter. The markings show the extra exposures given to various parts of the photograph.*

B *The final print with separate exposure times for each part. The basic exposure was 15 seconds.*

1. Now that you can see the whole print, is the exposure really correct?
2. Have you printed on the grade of paper best suited to the negative?
3. Are there areas of tone either too dark or too light that would benefit from local exposure correction?

At the primary stage it is possible to 'hold back' parts of the print to bring out detail that gets lost, or simply because the picture reads better. Conversely, parts of the print that look bleached out can be 'printed in', again to bring out detail that is lost in a straight print. Incidentally, very few photographs can be printed without some manipulation.

Printing is the craft part of the photographic process and printing or 'burning in' and holding back or 'dodging' local areas are the most basic controls and, like almost everything else discussed in this book, take practice to master. You will find your eye becomes more critical and, as time goes on, you will feel your hands develop more skill. This chapter starts with descriptions of the equipment needed.

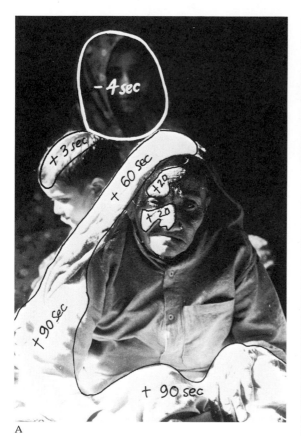

A

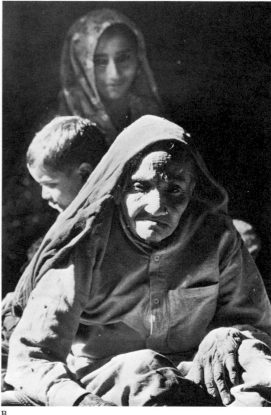

B

When you have seen the weakness of the print, decide which particular areas require holding back, choose the most appropriately shaped dodger and assess for what proportion of the total time you should cast a shadow over the area in question. Check skin tones particularly; if they are too dark the whole picture will look wrong, if too light the eye will be immediately drawn to them without feeling any satisfaction. Balancing the tones of the print so that it does not look awkward, with unimportant parts drawing unrewarding attention, plays a vital part in the manipulation of the print.

DODGING Make the print in the normal way, but hold back a part of it for a predetermined time by interrupting the image with a selected dodger, holding the dodger a few centimetres from the paper and moving it constantly so that no hard edge is formed. If you are unsure how long to hold it back, you can always put a small square of enlarging paper over the area for the assessed time and inspect this once it is developed.

A

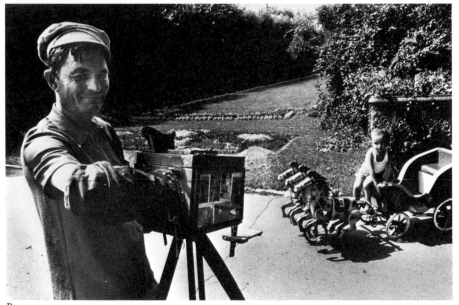

B

The cameraman in Romania needed holding back or dodging.

A *The print marked for varying exposures.*

B *The finished print.*

The basic exposure was 11 seconds.

BURNING IN with either a cardboard mask or your hands allows that part of the image requiring more than the overall exposure time a longer time to reach the enlarging paper. Experienced printers usually prefer the versatility and convenience of their own hands. Try framing a hole between your index fingers and thumb and hold

104

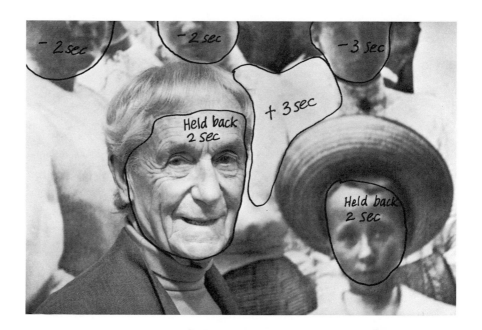

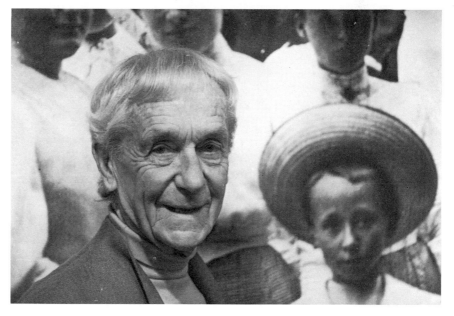

The portrait of Jacques Henri Lartigue, perhaps the greatest amateur photographer, needed little manipulation but it is extremely important to get realistic skin tones. In the corrected print the face was held back. Basic exposure was 12 seconds.

it between 15 and 20 centimetres (6 to 9 inches) below the lens. Again the amount of extra exposure has to be left to your judgement, but I think it will not take long before you begin to anticipate the response of the enlarging paper and can estimate the timing correctly.

Colour Printing

Cost rather than skill will be the main obstacle to making colour prints. Since the introduction of a simplified process for making good quality colour prints directly from transparencies the process is not much more difficult than making good black-and-white prints. In particular the development of an amateur version of the Cibachrome process, so that professional quality colour prints can be made with only three changes of pre-mixed chemical baths, can be likened to the introduction of the dry plate in the history of black-and-white photography, in that it made a process previously accessible only to those with a high degree of technical skill, accessible to anyone prepared to follow simple instructions.

For those interested in colour printing the most sensible way to start is to purchase a suitable processing drum, in appearance very like a multi-reel processing tank, which holds the paper during development, a set of colour printing filters, a pack of Cibachrome chemicals and paper, and the booklet published by Ciba which explains every stage in the process. It will not be helpful to repeat these instructions. They are simple to follow, and will enable first class prints to be made without experience. Nor is there space in this book to describe the more complex process of printing colour pictures from colour negative film. The purpose of this section is to provide a few general hints that may be useful in the production of prints using colour reversal materials.

Since both the paper and the chemicals are expensive wait until you have five really good transparencies that you can live with and which you will enjoy showing to friends. Select very carefully—you will never get good colour prints from over-exposed, washed-out transparencies.

To start with choose correctly exposed slides taken outside, in open sunlight. Cibachrome materials are balanced for transparencies taken under these conditions. The limitation of the process is that there is only one contrast grade of paper, so any transparency that is more 'contrasty' than normal requires a great deal of manipulation. It is to be hoped that Ciba can be encouraged to produce a couple of contrast grades.

You will often find, if you follow the advice on the exposure of transparency film, i.e. one exposure according to the meter and another exposure half a stop less, that the under-exposed, darker transparency will yield a better print, and the correctly exposed version a better slide for projection. If you take transparencies in

contrasty light you must take several pictures at progressively shorter exposures to be sure of getting a transparency you can print from. Under-exposing transparency film reduces the contrast.

As some of the intensity of the colour transparency is lost in the printing, and because you view a print by reflected light, not transmitted light, better results will often be obtained by exposing the film through a polarizing filter, which under most conditions increases the intensity of the colours. You will have to use faster film since the filter will considerably increase the exposure.

Keep transparencies spotlessly clean. Colour retouching is a real problem. Also the surface of the Cibachrome prints is very vulnerable to damage. Lacquer can be sprayed on by those who still do not object to depleting the ozone layer. A more healthy alternative is to buy plastic envelopes and store the prints in them or mount them behind glass.

Kodak do manufacture colour reversal paper (Ektachrome) and chemicals. As this is less expensive than Cibrachrome, but a little more tricky to use, many people start with Cibachrome, and when they feel confident switch to Kodak.

Technically colour photography becomes better and better. There is still a need for a larger range of high speed (400 ASA) transparency films with greater latitude, and I am sure it will not be long before other manufacturers increase their film speeds.

Transparencies which can be projected, easily reproduced in publications, and for special pictures printed on reversal paper seem to me by far the best way to use colour. They are also a great deal cheaper than colour negative film from which you have to make colour prints to assess the results. With transparency film you have the positives as the first step and for no extra cost these can be projected and viewed.

However, æsthetic problems of using colour film remain almost unsolved. It is extremely difficult to be aware of form, lighting, composition and colour. During the last few years a great many serious photographers have looked for a way to make colour photographs as powerful as their black-and-white images. Very few have succeeded, which should tell us something about the problem. So often one does not have the control over the juxtaposition of the colours which is why, very often, the photographer goes for subjects with very little colour variation. This seems an easy way out. Colour photography may begin to reveal its true personality when we see it as a medium distinct from black-and-white photography and all other forms of fine art.

Of course, for the photograph as a record and for the snapshot

colour is ideal, but the medium has yet to be upgraded to the status that black-and-white photography has acquired.

Retouching and Presenting Prints and Transparencies

Even when the print is dried improvements can be made. Mounted on to cardboard or framed behind glass a photograph has a more established look as well as being easier to look at. The first job, though, is spotting.

This is the kind of job one should not have to do on a nice day. But if you allow yourself enough time and do not rush the work it can be almost relaxing. There are many, many highly skilled techniques for altering photographs: backgrounds can be removed, expressions changed, people can be eliminated or added to a picture but none of these comes within the field of this book. What we are dealing with here is the disguising of marks caused by dust on the negatives which show as white specks on the print, and scratches, perhaps caused by careless storage of the negatives, which show as black on the print.

At this point I notice in other photographic books a stern warning is given about prevention being better than cure. I assume no one is going to want to spend hours painting in white marks on his new prints and that reasonable care will be taken of the film. Even so, sooner or later a spotting brush is bound to be needed.

Equipment

SPOTTING BRUSH Check that the hairs come together in a point. I use size 5 pure sable brush; it holds enough dye to paint out a lot of spots, so you can work uninterrupted when you have the right shade of grey mixed.

PALETTE This can be a piece of white glazed pottery from an old dish.

ENVELOPE FLAP The kind with glue you lick to stick it closed. The glue helps the dye to stick to glossy paper and take on the shine of the paper.

RETOUCHING PAINT I strongly recommend spotting with water-colour paint marketed for photographic purposes, as this can be removed from the print when mistakes are made. You need to buy a warm black and a natural white and use a mixture of the two dyes to establish a colour that matches your prints.

108

A RETOUCHING KNIFE AND FINE SHARPENING STONE Used for removing black spots.

A SOFT PENCIL may be substituted for the brush and dye for some retouching work on matt prints.

The main trouble I found when I first tried spotting was that the ink would not stay on glossy paper. You have to get the brush just moist enough but not too wet. Moisten the brush and wipe it over the glue on the envelope flap. When you can get the ink off the brush and on to the print you are face to face with the real problem, matching the ink in terms of density and colour to the surrounding tones. Tackle the spots in the darkest areas first, these are the easiest to lose. Make sure you have the colour of the ink matched correctly and allow yourself plenty of time. You are aware of the shape of the spot by its edge. Work to soften the edge bit by bit and gradually move into the centre. Anyone can do this kind of retouching but a lot of people do not have the patience for it. Convince yourself you have all day and somehow the retouching brush will be on your side. In fact there is some satisfaction in seeing blemishes disappear and you will find that after a bit of practice it is the kind of job that can be done while you listen to the radio. If you really find it difficult on glossy paper try using a matt paper—it is good for boosting your retouching confidence. In fact, one reason for making a print on this material is the comparative ease of retouching, so if you have any badly damaged negatives it is a good idea to use this paper. The dye is easily absorbed into the rough surface and will not show on the print. Retouching can be done with a soft pencil, but only on matt paper. To prevent the pencil rubbing off you must hold the retouched area above a jet of steam from the spout of a boiling kettle for a few seconds—the gelatine melts and merges with the pencil work.

KNIFING Make sure the blade is extremely sharp and lightly scrape density away from the black mark, stopping before you reach the paper base. Again lose the edges of the spot; this immediately makes it less noticeable. If there is texture around the spot mimic this with the knife so that your strokes follow the direction of the area you are working in. This is a tricky process; practise on test strips before attempting work on a good print. Work very, very slowly with fine movements, and remember, any action that depends on coordination between eye and hand helps in the taking of photographs. Knife and brush spotting is always done closer to the print than the

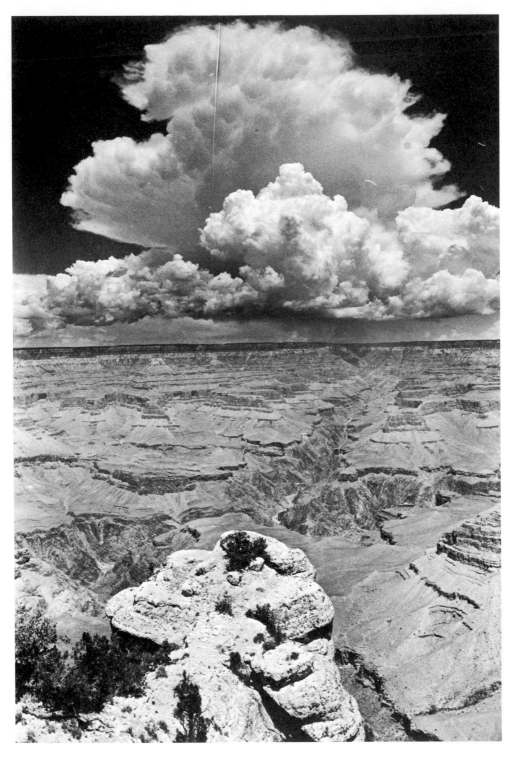

110 Retouching *The photograph of the Grand Canyon, shown earlier (on page 34) is shown here before the gash on the top was retouched.*

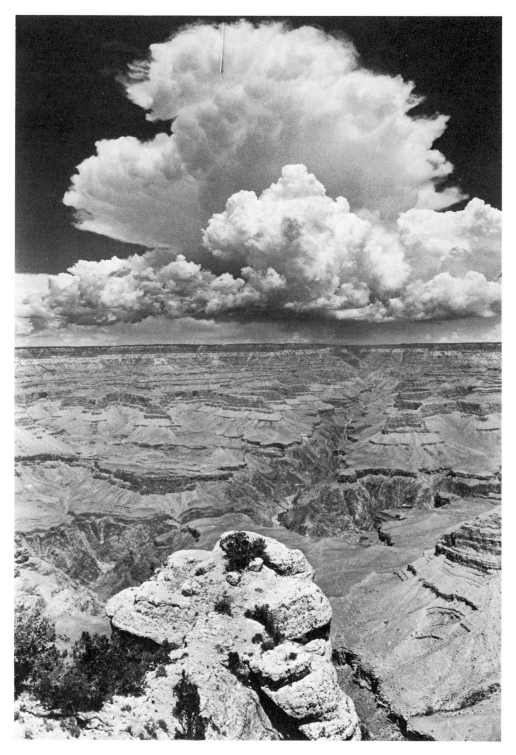

The white area is delicately painted in with dyes to mimic the surrounding texture and tones, then the black edge is carefully scraped away with a retouching knife. The print now shows half the black line removed and half the white gash retouched.

comfortable viewing distance, so, to check the visibility of the work, move back and look at the print from the normal viewing distance.

Presentation

Mounting undoubtedly improves the appearance of photographs. It can be done simply and inexpensively with Cow Gum, though other more elaborate processes will be found in the photo shop. My strong advice is, wherever possible improvise photographic techniques. Manufacturers have excelled themselves in finding the most elaborate and expensive ways to do even the simplest operation. These may make sense for the professional for whom saving time really does matter, but there is no reason for the amateur to get caught up in the strange world of business efficiency.

Spread the Cow Gum thinly on the back of the print and the mount and leave to dry for 15 minutes. Bring both surfaces together and rub the excess gum from the mount when the print is in position. Finally trim the mount with a hobby knife and metal ruler.

To my mind the best way of presenting a folio is to have all the photographs mounted on a uniform size of card; these can be handed around more easily than photo albums. But some people prefer showing them in book form, and the most popular albums around at the moment have clear plastic envelopes instead of pages. The photographs are placed back to back in the envelopes.

Cropping Photographs

Many professionals have gone on record as saying that they will never crop a photograph. The ones who do, tend to keep quiet. In my experience, certain pictures need an altered format or simply look better with a piece sliced off the side, top or bottom. Formulate your own views on the matter, but remember that it is obviously better to take photographs aiming to use the whole negative area since the degree of enlargement for a given print size must increase if only part of the negative is used.

These are photographs I have cropped and to my mind improved them by doing so.

A *The photograph of Ebba and Sauren on page 16 was made from part of a negative. This is the whole image with the left side included. There is no visual information recorded there and again the photograph looks better when this area is cropped.*

B *The picture of the funeral was made from the whole of the negative on page 30. Here is a print made from the same negative without the left-hand side. The image has become more compact and is easier to read.*

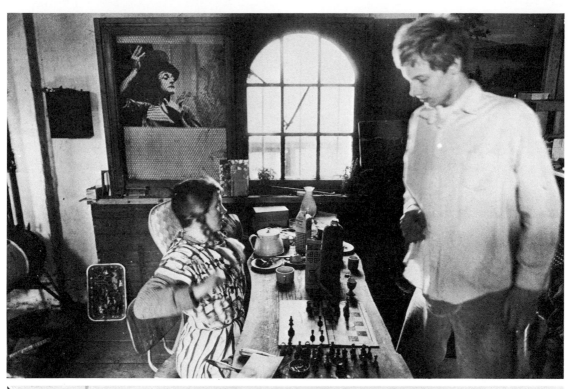

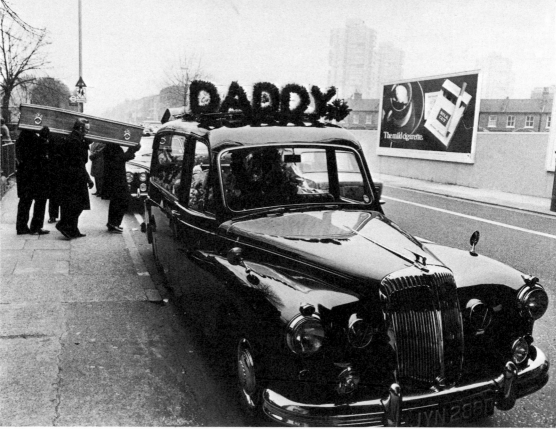

Economy

Inflation has caused the price of photographic materials to rise to a point where the economy measures suggested in this chapter are well worth practising, despite the inconvenience that bulk buying entails. In nearly all cases powdered chemicals are cheaper than liquids. A high percentage of the cost of small cartons of chemicals goes on packaging. If you buy a large carton of developer or fixer the percentages are reversed; more of your money is actually used to buy the chemicals, while the packaging costs remain almost the same. If you do not use large quantities of developer I suggest you form a photographic collective. Buy the largest cartons practicable, mix carefully, and divide the solutions between the members of the group, keeping solutions in the Air-Evac containers or bottles filled with marbles. Do not try to measure out half a carton of powder developer diluted with the same fraction of water, since you will not get an even mix of the chemicals that make up the solution.

Prices are changing so rapidly that it is pointless to quote them, but you could expect to reduce the cost of either Ilford 10-11 or Kodak D76 developer by 60 per cent if you bought a 2·5 litre pack instead of four 600 ml packs. For all practical purposes these developers are identical, produce excellent negatives and keep for six months if stored as advised. Before use you can dilute them 1:1 with water or use neat and increase development times to compensate for exhaustion. Microdel X, a fine grain developer, is 30 per cent less in any packaging than D76, but I have never got really good results from it.

D163 print developer in a 2·5 litre pack which makes 10 litres working strength developer, costs 45 per cent less, litre for litre, than the same substance packed in a 1-litre box. This is my favourite print developer; but never buy it as a liquid—it costs twice as much.

Fixer keeps extremely well. Just get hold of some large plastic containers and buy the biggest carton possible. Unifix powder, an all-purpose acid hardening fixer, good for films and papers, costs 75 per cent less, gram for gram, if you buy a 5 litre carton instead of a 500 gram carton.

Daylight-loading Bulk Film

Enormous savings can be made by buying black-and-white and colour film in 30 or 17 metre lengths. For the cost of $8\frac{1}{2}$ 36-exposure

films loaded into the cassette by the manufacturer, you get 17 from a 30 metre roll. You will need a supply of cassettes, and I suggest that you phone round the local shops and processing labs (see Yellow Pages) to obtain them, or buy them from mail-order dealers for a few pence. Use them only once if they have already been used. New ones, provided that you take care to keep the felt really clean, may be used twice, but not more.

With bulk film loaders you can wind the film into the cassette in daylight once the roll of film has been put into the machine. If you do not have a darkroom and prefer not to stay up until it is dark enough, this operation can be done in a changing bag. It seems sensible to me to share the cost of the film loader and changing bag with friends. If you do not know anyone in your area interested in working this way, you could advertise in one of the well-read photo magazines. You will rapidly recover the cost of the extra equipment, but there is a disadvantage: most film loaders fog the end of the film and although they tell you how many frames you have in the cassette so that you can stop shooting two frames before the film is used up it is easy to forget.

A more expensive daylight loader, available in two sizes—one to take 17 metre lengths, the other up to 60 metres—is now available, which, if used correctly, will not fog the end of the film. It is called the Fullfix.

DAYLIGHT LOADER Another advantage of buying bulk film is the facility of loading short lengths into cassettes, for special jobs not requiring 36 exposures.

Colour film can also be purchased in bulk, for example Kodak's Ektachrome ER5257 is a 35 mm 64 ASA daylight film and makes 17 36-exposure lengths for the price of 12 cassetted films, but you can engineer a further saving by winding up to 44 frames into the cassettes. In my experience no extra charge is made for processing this longer than normal length, though I have never tried sending it to Kodak! Make sure you label all self-loaded cassettes clearly, especially if you are having them processed by a custom laboratory.

Slightly out of date black-and-white film costs even less than the figures I have quoted, but you take a small risk. Always test a short length as some exposure increase may be necessary. I would never recommend outdated colour film, however cheap, as colours change horribly.

ENLARGING PAPERS The first economy you can make does not involve bulk buying and applies to users of 35 mm, the picture format of which does not conform to most of the popular paper

sizes. Enlarge a 35 mm negative to the edges of a piece of paper $25 \cdot 4 \times 20 \cdot 3$ cm (10×8 in) and you waste a strip $3 \cdot 5 \times 25 \cdot 4$ cm—about 15 per cent. Now if you buy A4 paper, $21 \times 29 \cdot 7$ cm, and cut it into two pieces $21 \times 14 \cdot 85$ cm, you waste only $1 \cdot 1 \times 21$ cm—about 7 per cent. For a larger print, you can buy paper $30 \cdot 5 \times 40 \cdot 6$ cm, cut it to make two $30 \cdot 5 \times 20 \cdot 3$ cm and there is almost no waste at all. A box of 100 sheets (to make 200 prints) would save you between 20 and 25 per cent. Further savings can be made by shopping around for papers that are 'out of date'. They will be slower than fresh material and may not produce as good a black. If not suitable for folio prints, however, they could be useful for contact sheets and proofing. Actually paper is not date-stamped, which would indicate a good shelf life. Kodak's P84 paper designed for graphic designers is very suitable for proof printing and costs about a third less than single-weight paper.

Photographic discount houses selling mostly by post can sometimes further reduce the cost of products to their customers; they advertise widely in the popular photographic magazines. In the long run, however, you may well be better off building up a good relationship with a local photographic shop, which will be concerned to provide a comprehensive service and will take the time and trouble to order special items, as well as looking after the servicing of equipment, a side of the business often skimped by discount houses.

Selection

This is extremely important. Mount only the very best prints for your folio. It is not good tactics to have friends plough through hundreds of pictures amongst which inevitably the mediocre prints swamp the good ones. It requires a special discipline to weed out the almost-rans, but make yourself do it. Twenty of your best pictures will leave people genuinely impressed and looking forward to seeing more of your work as you produce it.

If you use transparency film, the temptation to project too many slides is even greater. It is so easy to drop a few extra in the slide tray in case someone likes them, and the result is that most slide shows last far too long. This is worse for your audience because they are trapped in a darkened room viewing the pictures at your speed. When you organize a slide show, get everything ready before your guests arrive, make the selection as tight as possible, run the chosen few through the projector once to check that they are the right way

116

round and, when everyone is ready, black the room. As you project the pictures, try to sense how long to hold each image on the screen. Audiences send out signals continually, giving you all sorts of information; you have to learn to read them correctly. This is also part of photography.

Finally, I really hope that this book provides the information you need to *enjoy* photography. There are many other ways of using the camera and materials—this is only a start. Make the most of your photographs, pin them on the walls, give them to friends, send them through the mail, and keep in touch with the galleries that show photographs.

Bryce Canyon after a rainstorm.

Yellow filters will help to remove a slight haze by absorbing ultra-violet light and improve the shadow contrast.

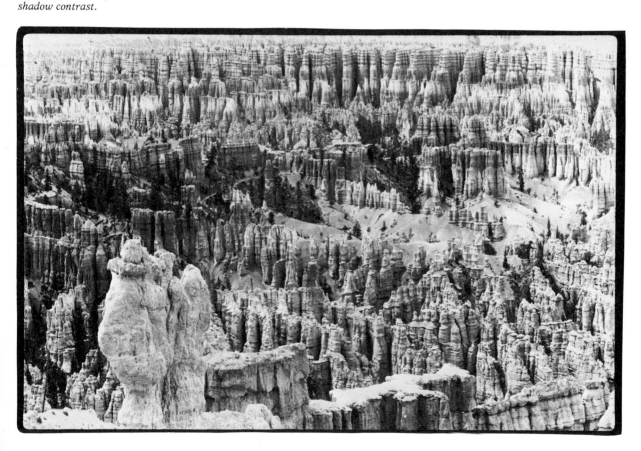

APPENDIX

General Filters for Black and White

Filter	Exposure increase (Filter factor)	Effect
yellow	2 × –3 ×	Lightens yellow; darkens blue. Increases sky contrast by absorbing blue light and thereby rendering blue sky darker and white clouds more pronounced. Removes slight haze by absorbing ultra-violent light to which film is sensitive although the human eye is not. Improves contrast of buildings against sky. Improves shadow contrast and texture of snow scenes.
orange	4 × –8 ×	Lightens red, orange and yellow; darkens blue and green. Used to be called a furniture filter because it lightens the tone of wood, making the dark areas of grain stand out. Penetrates heavy haze, so good for distant landscapes. Turns blue sky almost black. Subdues skin blemishes and freckles. Enhances surface texture of brick and stonework.
red	6 × –10 ×	Lightens red and yellow; darkens blue. Used for dramatic sky effects—blue sky records as black, particularly when the camera is pointed away from the sun (sky near the horizon will record as a paler tone). Cuts through heavy

Filters with an asterisk are used with colour and black-and-white film. See page 120 for a description of their use with colour film.

A yellow filter was used here to darken the blue sky, showing the clouds in a more natural way. For a more pronounced effect a red filter could be used, as in the photograph of the Grand Canyon. The red filter absorbs all of the blue colour, making the sky appear black.

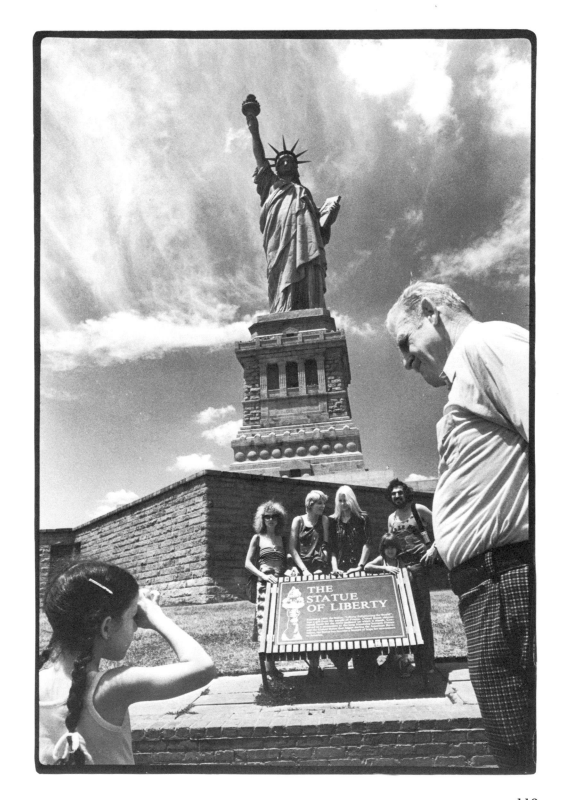

Filter	Exposure increase (Filter factor)	Effect
		haze. Excellent for light architecture against blue sky.
polarizing filter*	approx. 3×	Acts something like a venetian blind by admitting light waves vibrating in one direction only. It is mounted in a filter holder that allows it to rotate and is used to eliminate unwanted reflections from gloss and many polished surfaces. Expanses of water can be lightened or darkened by rotating the filter. Light from a clear blue sky photographed at right angles to the sun may be lightened or darkened without changing other tones in the photograph. It has good ultra-violet absorption, so penetrates haze. Combined with a yellow filter, will strongly darken skies, leaving other colours relatively unchanged.
Ultra-violet or haze filter*	none	Eliminates only ultra-violet rays which come to a focus slightly in front of the film and may, when the aperture is wide open, result in poor definition. Protects the front element of the lens without changing the tones or exposure.
neutral density*	2×–10×	Reduces light intensity without affecting tones or colours, enabling exposures to be made at wider apertures or slower shutter speeds. Neutral density filters have good ultra-violet absorption. Perhaps their most useful application is to make it possible for flash pictures to be correctly exposed when the flash unit is very powerful or near to the subject, or when a wide aperture is needed.

General Filters for Colour only

Filter	Exposure increase (Filter factor)	Effect
polarizing filter	approx. 3 ×	As well as performing all the functions described in the section on filters for black-and-white, a polarizing filter will produce deep blue skies without affecting other colours.
neutral density		See description of filters for black-and-white.
ultra-violet and haze filters	none	Help to prevent slight blue cast without affecting other colours in distant scenes, aerial shots, mountain pictures, sunlit snow scenes and photographs taken near water.
skylight	none	Stronger action than haze filters; removes blue cast in situations described above and adds warmth to transparencies.

Conversion Filters for Colour Transparency Film

Filter	Exposure Increase	Colour film type
Wratten 80A	2 stops	Daylight film, balanced for 5,500 °K, to be exposed in tungsten light of colour temperature 3,200 °K.
Wratten 80B	$1\frac{2}{3}$ stops	Daylight film, balanced for 5,500 °K, to be exposed by photo lamps of colour temperature 3,400 °K.
Wratten 81A	none	Artificial-light film, balanced for 3,200 °K, to be exposed by photo lamps of colour temperature 3,400 °K.

Filter	Exposure Increase	Colour film type
Wratten 82A	none	Artificial-light film, balanced for 3,400 °K, to be exposed by photo lamps of colour temperature 3,200°K.
Wratten 85	$\frac{2}{3}$ stop	Artificial-light film, balanced for 3,400 °K, to be exposed in daylight.
Wratten 85B	$\frac{2}{3}$ stop	Artificial-light film, balanced for 3,200 °K, to be exposed in daylight.
BDB Filtran FLD filter gives considerable improvement in colour reproduction		Daylight film to be exposed by fluorescent tubes.

BDB engineers have recently introduced a new range of Filtran filters. These filters correct colour casts in daylight film in certain conditions.

Filter	Exposure Increase	Effect
R $1\frac{1}{2}$	$\frac{1}{3}$ stop	Corrects slightly blue cast in open shade or, on an overcast day, caused by cloud filtering out warm colours. Also absorbs excess blue light from electronic flash.
R 3	$\frac{1}{3}$ stop	Prevents stronger blue cast especially at midday caused by shadows or wide expanses of blue sky or sea and, on heavily overcast days, should also be used when photographing mountains and at high altitudes.

Filter	Exposure Increase	Effect
R 6	$\frac{2}{3}$ stop	Particularly for use at very high altitudes and in extremely overcast conditions.

Safe-light Testing

1. Switch the safe light off, and in the enlarger expose a sheet of paper in the normal way to a negative containing a large expanse of highlight area.
2. Place the exposed paper at the normal working distance from the safe lamp and cover half the paper with a piece of cardboard.
3. Take a second piece of cardboard, switch the safe lamp on, and cover successive areas of the remainder of the picture so that they receive exposures to the safe lamp of 30 seconds, 1 minute, 2 minutes, 4 minutes and 8 minutes.
4. Switch the safe lamp off and develop the material in total darkness for the usual time.
5. Examine the resulting print closely to see which of the five test areas merge indistinguishably into the part of the picture that has not been exposed to the safe lamp, and also to see which area shows an increase in density. This shows how long the exposed material can be subjected to safe-light illumination without discernible effect on the image density.
6. If this time is not appreciably more than the usual handling time for the material, the intensity of the safe-light illumination should be reduced by, for example, moving the safe lamp to a greater distance from the working area.
It is worth repeating this test after you have used a safe lamp for a few years, since safe lamp filters seem to become less effective in time.

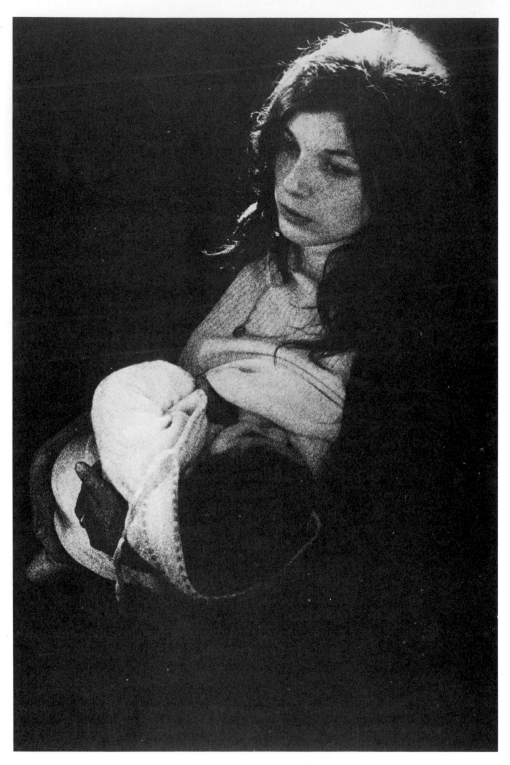

Often the grainy appearance of a film adds a new dimension to the picture.